PORTRAITS AND
PEOPLE

Capturing life and character

CASSELL

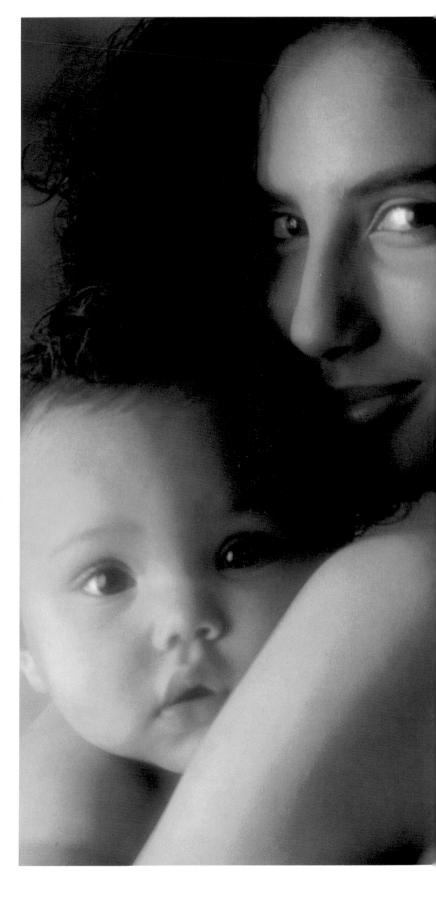

ACKNOWLEDGEMENTS

Front cover; (main) Mike Henton/Eaglemoss, (top inset) TIB,
(centre inset) TIB/David De Lossey, (below inset) TSI, 1-3 ICL, 4
RHPL, 5-6 ICL, 7-14 Michael Busselle/Eaglemoss, 15-18 Mike
Henton/Eaglemoss, 19(l,r) TIB, 20(t) Caroline Summers, 20(b) TIB,
21-24 George Wright, 25-28 Toby Corney, 29-32 Kim
Furrokh/Eaglemoss, 33-40 Tobi Corney/Eaglemoss, 41(t) TIB,
41(b) Chris Kapolka, 42(bl) Philip Dunn, 42(br) Operation Raleigh,
42-43 TIB, 43 TIB, 44(t),(l) TIB, 44(b) Zefa, 45-48 Michael
Busselle/Eaglemoss, 49-52 Ray Moller/Eaglemoss, 53-56 Vincent
Oliver/Eaglemoss, 57(t) Steve Tanner/Eaglemoss, 57(b) TIB, 58-59
Steve Tanner/Eaglemoss, 58(tr),(c) TIB, 58(l) Graham
Rae/Eaglemoss, 58(b) ICL, 59(t) TIB, 59(b) Swift Picture Library,
60(t) Jonathan Vince, 60(b) Steve Tanner/Eaglemoss, 61(t)
Bubbles/Jenny Woodcock, 61(b) Collections/Anthea Sieveking,
62(t) Reflections/Jenny Woodcock, 62(b) Bubbles/Loisjoy
Thurstun, 63(t) Roger Howard, 63(b) Zefa, 64(t) TSI, 64(b) TIB, 65(t)
George Wright, 65(b) TSI, 66(t) Allsport/Tony Duffy, 66(b) TSI, 67-
70 Fiona Pragoff/Eaglemoss, 71-74 Ray Moller, 75 TSI, 76 Zefa,
77(l) Adam Eastland, 77(r) Collections/Anthea Sieveking, 78(tl) ICL,
78(b) TIB, 78-79 TSI, 79(b) Collections/Anthea Sieveking, 80(tl)
Dev Raj Agarwal, 80(tr) Zefa, 80(b) TIB, 81-84 Jenny
Woodcock/Eaglemoss, 85-88 Ray Moller/Eaglemoss, 90-92 Mike
Henton, 93-96 Jerry Young/Eaglemoss, Back cover Zefa.

Key: ICL - Images Colour Library; RHPL - Robert Harding Picture Library
 TIB - The Image Bank; TSI - Tony Stone Images

Consultant editor: Roger Hicks

First published 1993 by Cassell
Villiers House, 41/47 Strand, London WC2N 5JE

Copyright © Cassell 1993
Based on *Camera Wise*
Copyright © Eaglemoss Publications Ltd 1993

Distributed in Australia
by Capricorn Link (Australia) Pty Ltd
P. O. Box 665, Lane Cove, NSW 2066

British Library Cataloguing-in-Publication Data
A catalogue record for this book is available from the
British Library

ISBN 0-304-34351-X

Printed in Spain by Cayfosa Industria Grafica

CONTENTS

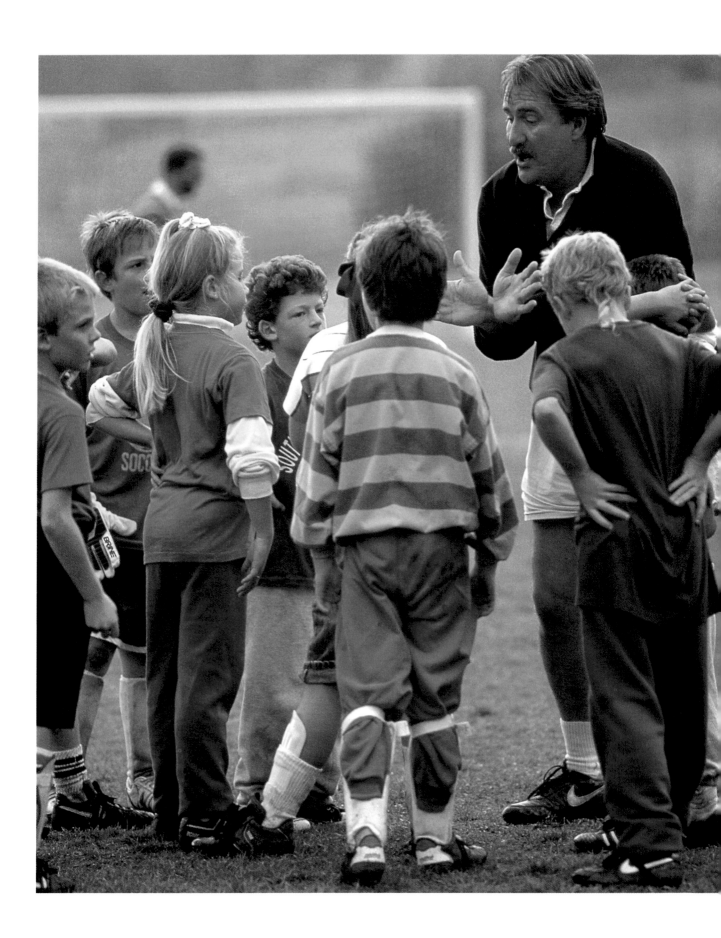

INTRODUCTION

OUR predecessors wanted a portrait to be "a good likeness"; and they have left us those likenesses, in their stiff-starched clothes and Sunday best, glowering at the camera.

Today we ask for more. We ask for a portrait which tells us something about the person in the picture; we ask almost for a potted biography. As well as being a faithful representation of the outer person, a successful portrait should help us to reach the personality which lies behind the mask. Is the subject happy or sad, stern or gentle, bold or timid?

Just as the borders between formal and informal portraits have almost disappeared, so have the borders between informal portraits and candid shots. Thus, we seek clues to the subject's character and even their lifestyle in the way the portrait has been set up - the clothes they are wearing, for instance, or whether the portrait has been taken at home, at work or at play.

A series of sensitive portraits can also grow into a sort of potted history. The baby in the cot becomes the toddler exploring the world ... the ten-year-old girl on ice-skates ... the young woman in the graduation picture ... the mother of that baby in the cot...

All this means that the photographer of people faces endless challenges, whether he is attempting to distil a person's character into a single picture, or trying to build a set of photographs which show that person in all of his or her complexity. While this may sound daunting, achieving successful portraits is, in fact, easier than it seems.

The pages which follow explain a host of techniques which belong in the successful portrait photographer's repertoire. You will rarely need to use all of them at once: surprisingly often, there is a single "key" which transforms a mediocre shot into a superb portrait, and still more often, there are two or three techniques which can be used together.

Do you want someone to look more important? Lower the camera angle. You want to emphasize a strong character? Use harsher lighting. You want a man to look solid and reassuring? Give him a pipe. You want children to look natural? Give them something to do, and photograph them when they have forgotten that the camera is there.

This volume contains intimate masterclasses in which a professional guides an amateur through the steps he needs to go through in order to achieve the effect he wants. There are also numerous profiles of top-class, professional portrait photographers giving you inside information about the equipment and skills which help them create the pictures which have made them famous.

The vast majority of circumstances in which you want to photograph family and friends are covered. Whether you want a picture for the family album, a portrait to hang on the wall, or a photograph for your grandchildren and their grandchildren, you will find what you need to know in the following pages.

Better informal portraits

Most of the time, most of us take informal portraits; so we start with a Masterclass from Mike Busselle.

◀ David Jones is a photographic journalist and a keen amateur photographer.

▶ Mike Busselle is a well known professional who specializes in portraiture and landscapes.

When Mike and I met up for this Masterclass session, we wanted to photograph our 'volunteer', Jo, in the great outdoors. We were looking for a relaxed and informal portrait and to make it fair we decided to use the same camera – an Olympus AZ 330 zoom compact.

The day started out fine. But by the time I was ready to begin shooting rain was pouring down and the sky had turned dark grey.

Outdoor shots were obviously out of the question so we decided to try Mike's conservatory instead. Its glass sides and roof created a 'controlled' outdoor situation so we could use natural light rather than flash. I set up and began shooting.

Why doesn't it work?

What I'm looking for is a shot that's natural but flattering. I take photos of Jo sitting in the middle of the room, standing up and perched on a stool in the corner – but however I ask her to pose I can't quite get the effect I want.

For a start, the room is cluttered with wicker chairs, pot plants and bright cushions. I move some of the plants and think about clearing the surroundings. In the end, though, I don't have the courage of my convictions and put up with a distracting background.

To get eye level contact I crouch down, hoping this will improve my picture. But it's self defeating: I'm so busy keeping my balance I don't take enough notice of how the top light is affecting Jo's face and – even worse – I don't involve Jo in what I'm doing.

By now I've spent too long preoccupied with this and that – I'm disappointed with the way things are going and decide that it's time to hand over to Mike. I knew there were several things wrong with my picture – like the distracting background and the top light on Jo's face – but I didn't have the confidence to change them. Unfortuately, I ended up settling for a half-hearted attempt.

▼ David took most of his pictures squatting uncomfortably in front of a slightly self conscious Jo.

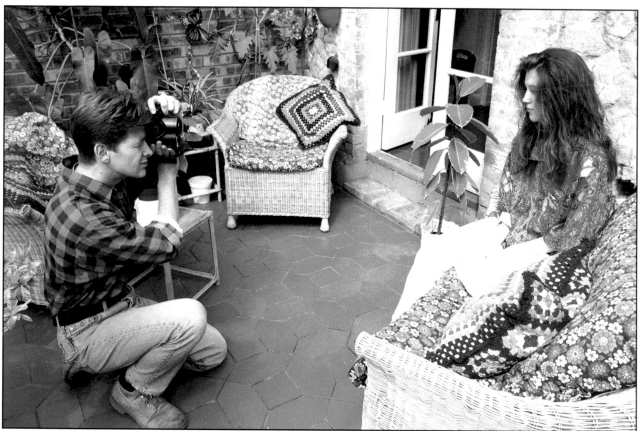

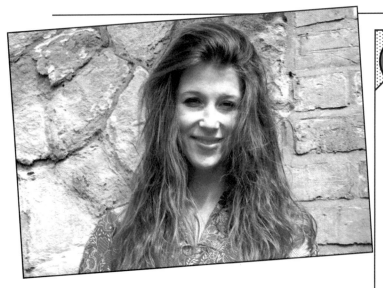

▲ *Jo looks rather lost and awkward in David's portrait. The background is uneven and distracting, the subject fills less than half the frame and too much top light has obscured her face in deep shadow.*

Tip

Working with a tripod

Mike Busselle says: 'If there's one thing that distinguishes a professional's portraits from those of an amateur, it's the use of a tripod. Pros always use them, but amateurs seldom do.

'That's a pity, because a tripod can greatly improve your portraits – it eliminates shake, allows you to compose and control the shot and helps increase your confidence.'

Here the tripod helps Mike photograph from that awkward height below his eye level but above squatting level. In any case squatting isn't ideal – when David tried it he rocked around on his heels and ended up worrying more about his balance than he did about his camera.

MIKE TAKES OVER

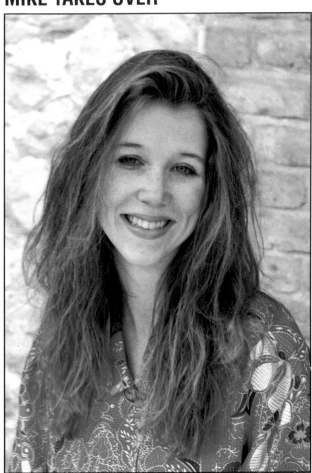

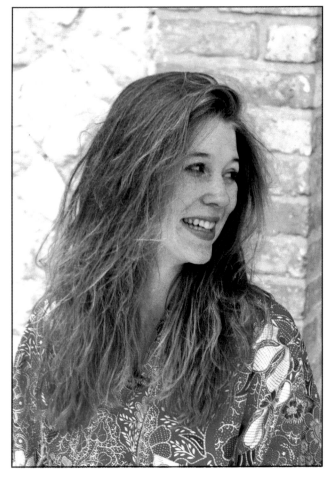

1 FORMAT AND LIGHTING
Mike changed the format so that Jo filled the frame. He reduced the glare from above by pulling a window blind across the roof. To fill in the shadows he laid a large polystyrene board against a stool.

2 RELAXING THE MODEL
Mike knows that the best photos come from a relaxed shoot where everyone is enjoying themselves. So he began chatting and joking with Jo, and soon succeeded in putting her completely at ease. She looks much more relaxed but the uneven background is causing problems.

The professional touch

The first thing Mike did was mount the compact on a tripod. This let him control the composition and look up and talk to Jo without losing the shot. He chatted away to Jo, who quickly relaxed. It made it more fun for him too – I'd been a bit tense.

Then he sorted out the busy surroundings: he moved around the room until he found a likely looking spot where the background was uncluttered.

Next, Mike set about controlling the available light by using a large polystyrene board to reflect it on to Jo. He toned down the top light by pulling a blind across the roof. (If you've no blind at home, an old sheet fixed with drawing pins will do just as well.)

The lighting set up

Natural light – occasionally sunny, mostly overcast – streamed in through the glass roof and windows. A plain blind pulled across the roof softened and warmed the top light. Mike also controlled and reflected this light back on to Jo's face by leaning a polystyrene board against a stool. This gets rid of the deep shadows in her eyes and under her nose and cheeks.

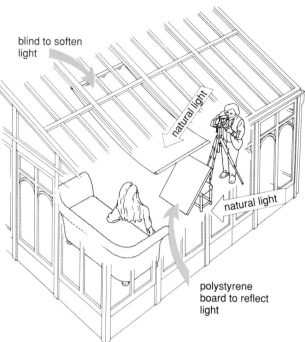

blind to soften light

natural light

natural light

polystyrene board to reflect light

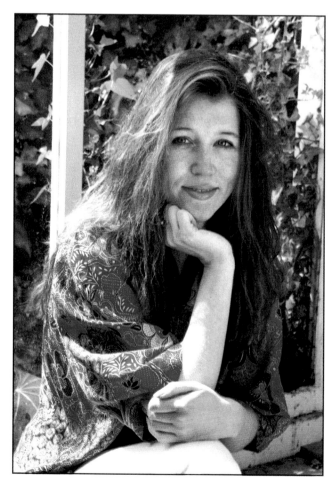

3 CHANGING THE BACKGROUND
Unhappy with the sandstone and brick splitting the picture in two behind Jo's head, Mike moved her over to a window where there was more light and less distraction. But Jo wasn't sure exactly what to do with her hands and there's still too much going on in the background.

4 SIMPLIFYING THE SHOT
Mike removed the cushions and covering from a wicker chair, sat Jo in front of it and used it as a background. It's a good idea, as it provides a natural, plain background and gives Jo something to do with her hands – a good example of how you can adapt a room to your needs.

Where I really fell down was not involving Jo. I was so wrapped up in technical problems that I forgot the obvious – I was photographing a person not a dummy. I should have been more friendly and talked to her a bit more – as it was I couldn't get her to relax and smile naturally. Using his tripod, Mike was free to take his eye away from the viewfinder and chat to Jo whenever he wanted.

I also learnt more about controlling the lighting. I could see that Jo's forehead and nose were catching a lot of glare, while her eyes were plunged into deep shadow, but didn't know how to go about solving the problem.

Compact tips

❏ Mike and David used an Olympus AZ 330 zoom compact with a 38-105mm range. As with most compacts, exposure, shutter speed and focus were all automatic. They used ISO 400 print film to deal with bad light at the start of the day. The camera was mostly used zoomed to its full extent, giving good close-ups with no danger of distortion.

❏ If your camera doesn't have a zoom lens, don't be tempted to move too close to the subject just to fill the frame. A very close viewpoint can distort the model's features – too big a nose is a common example. You'll get better results if you frame the picture slightly less tightly and settle for a head and shoulders shot or crop the picture at the printing stage.

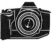

SLR tip

❏ Most SLR cameras allow you to operate the camera from a distance using a cable release. This gives you more freedom to move around and talk to the model without having to return to the camera to take the picture.

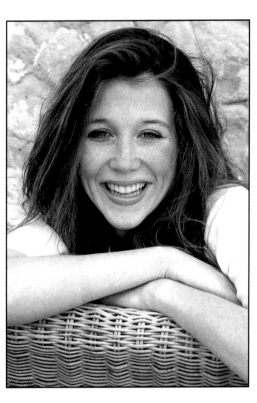

▲ *Turning the chair around, Mike asked Jo to lean over the back of it. He made sure she was sitting comfortably and feeling relaxed before he took this warm shot of her in a plainer and less distracting outfit. The result – a friendly portrait full of vitality.*

▶ *Going in close means Jo's face fills the frame, and the natural light brings out her features. She has changed her pose but still looks relaxed and Mike has used his tripod to take the shot from slightly above her. She's looking up – always a flattering angle.*

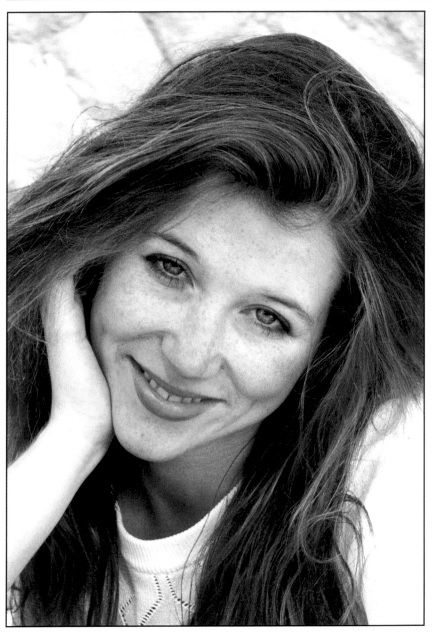

Creating a character study

The next step after informal portraits is to concentrate on the sitter's character. Mike Busselle shows Martin Elliot how it's done.

Shooting a character study can be tricky because you have to tread a fine line between flattering your sitter and revealing lines and wrinkles to add interest. That's where Mike Busselle's considerable experience came in handy when I invited him to show me how it's done.

Our venue was Mike's studio, where we were joined by Frank, a retired actor who had agreed to be our subject for the day.

Starting out

I had first go. I used a Nikon FE2 SLR with a 50mm lens and Kodak Ektachrome Professional ISO 64 slide film. I mounted the camera on a tripod so I could easily talk to Frank while taking pictures instead of being hidden behind the viewfinder.

I decided to use a simple lighting set up – one fairly high power studio flash linked to the camera by an extension lead. You could use a pocket flashgun off camera for less powerful light. The flash was positioned in front of Frank and slightly above his head. This showed up his face clearly, but gave a rather flat light which made its contours less obvious and left a hard shadow under his chin.

The resulting picture is a nice enough portrait, but I knew it could be developed to show more of Frank's character.

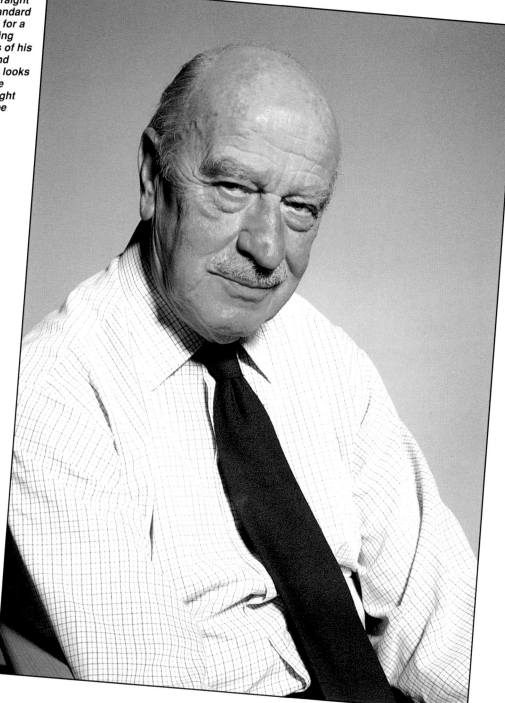

▶ *Martin, the amateur, took a straight head-on shot of Frank with a standard lens. Mike thought it wasn't bad for a first attempt. However, the lighting doesn't emphasize the contours of his face enough, and the background colour is rather inappropriate. It looks as if Frank is just slumped in the chair – Martin should have thought more about which pose would be most photogenic.*

Tip — Using make up

You may find your subject has a shiny nose or forehead. This is likely to be exaggerated by flash. Applying face powder helps tone down the shine. If your subject is unwilling, remind them that actors always wear make up for the camera!

Mike's approach

Mike started off with the same camera I'd used. The first thing he did was to darken both Frank's clothes and the background. Always ask your 'model' to bring at least one change of clothing so you have plenty of options.

So far Mike had used a 50mm lens. He switched to a 70-210mm zoom as he could frame Frank's head tightly without distortion. This let him change focal lengths without having to shift the tripod too much.

Lighting tricks

Mike then turned his attention to the lighting. He had begun with a studio flash in the same position as I used – in front of Frank. However, Mike wasn't happy with the effect – the subject's face looked flat and the lines were not obvious enough for a character study.

He switched off the frontlight and replaced it with a slightly less powerful sidelight, positioned to Frank's left. Sidelighting created shadows and brought out the contours of his face. Indoors or out, sidelighting is often the best choice for portraits.

'For a study of Frank that really brings out his character', said Mike, 'the most important thing is to get the lighting right. We don't want frontlighting as this removes shadows from the subject's face, and it's shadows that we're after. To bring them out we need to light from the side.

'Think of how sunlight varies during the day. At noon when the sun's overhead you have the equivalent of toplighting – very flat with short shadows. But near sunset or sunrise the sun gives you what is effectively sidelighting and so the shadows are longer and much more prominent.

'It's the same thing in portraiture. To emphasize shadows, light your subject from the side, not the front.'

MIKE TAKES CHARGE

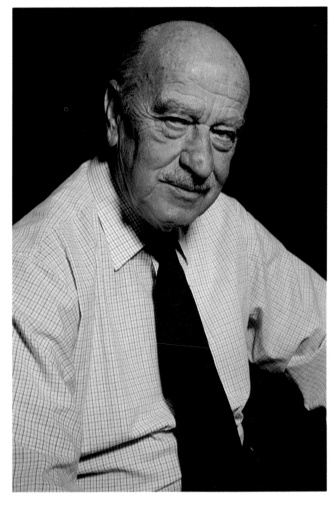

1 A DARKER BACKGROUND
The first thing Mike did was to darken the background. He hung up a roll of dark backdrop paper and explained, 'We'll be creating lots of shadow over Frank's face so it's going to be fairly dark in the final shot. The background and his clothing need to be dark as well, otherwise the effect will be spoilt.'

2 DRESSING THE PART
Mike asked Frank to change into a brown shirt and dark waistcoat that he had brought with him. The waistcoat adds interest and 'personalizes' the shot while the pale shirt ensures that Frank's head doesn't appear to be floating! The result says more about Frank than Martin's picture.

 ## SLR tip

 ## Compact tip

Choose an aperture which allows enough depth of field to record your subject sharply – but not the smallest aperture if you want to throw the background out of focus.

For portraits, choose a shutter speed of at least 1/60th sec so that your subject doesn't have to stay still for an uncomfortably long time.

If you own a dual lens or zoom model, use the longest focal length when you're taking close-up portraits. This creates a more flattering picture.

If your compact has a fixed lens, you may find that taking a step back from your subject improves the shot – although you'll fill less of the frame.

The lighting story

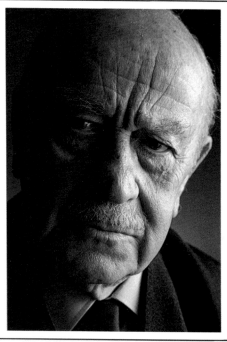

4 A SOFTER LIGHT

Mike replaced the front flash with a smaller flash to Frank's left. He put some tracing paper in front of the flash, because 'the screen helps spread the light out and gives a softer image'. But half of Frank's face was still plunged in shadow.

3 TIGHTER FRAMING

Mike switched to a 70-210mm zoom, set at 100mm. 'I want a tight head and shoulders shot of Frank', he explained. 'With a standard lens I'd have to move in closer and that would make the picture look distorted.' Frontlighting had produced an ugly shadow under Frank's chin, so Mike's next task was to alter the lighting.

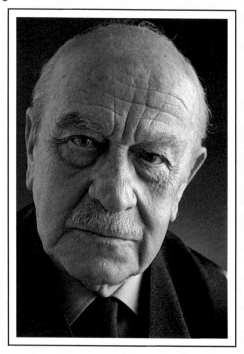

5 ADDING A REFLECTOR

Mike used a large sheet of polystyrene as a reflector to bounce light into the right side of Frank's face. This brought that side out of shadow, but he still wasn't completely happy with the arrangement – the camera angle emphasized Frank's forehead.

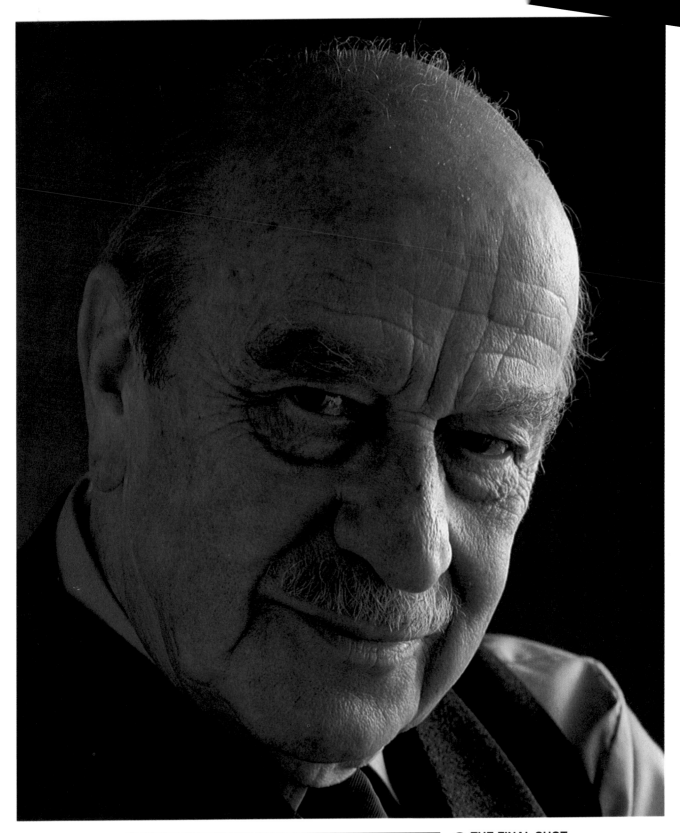

The final set up

The shoot took place in Mike's studio. You could use a sitting room just as well as a studio so long as you can make the background plain. The set was very simple – one chair for Frank to sit on and a plain background. The lighting was provided by one studio flash. Instead of this, you can use a flashgun linked to the camera by a sync cord.

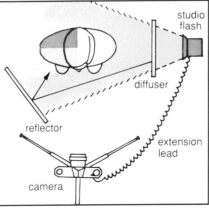

studio flash

diffuser

reflector

extension lead

camera

6 THE FINAL SHOT

Mike asked Frank to turn his head to the left so that he was no longer directly facing the camera. Mike used a slightly lower camera angle for a more sympathetic viewpoint, with less emphasis on Frank's forehead. The end result is a very pleasing character study with soft, moody lighting.

Portrait with natural light

Natural light is generally softer than flash, so it's perfect for close portraits. But when you're using window light, controlling and reflecting it is of vital importance. Mike Henton and David Jones try a formal indoor study.

A good formal portrait of a friend or relative is a lovely memento. But taking indoor pictures that do your loved ones justice isn't easy. Flash can be very harsh, and hiring a set of studio lights is quite a business. Natural light is a much cheaper alternative, and can be very effective provided you control it.

The available light was good when Mike and I started, with plenty of early morning winter sunshine. So once our model, Jo, arrived we went straight to work.

Uneven light

I set up my shot first. I asked Jo to sit facing the window and then turn her head sideways so that she was looking straight into the camera. I thought this would ensure that there was enough light. I used a Nikon F3, ISO 200 colour slide film and a standard 50mm lens.

I was quite happy with the composition of my shot. Jo looks comfortable and relaxed, and the side on approach is interesting.

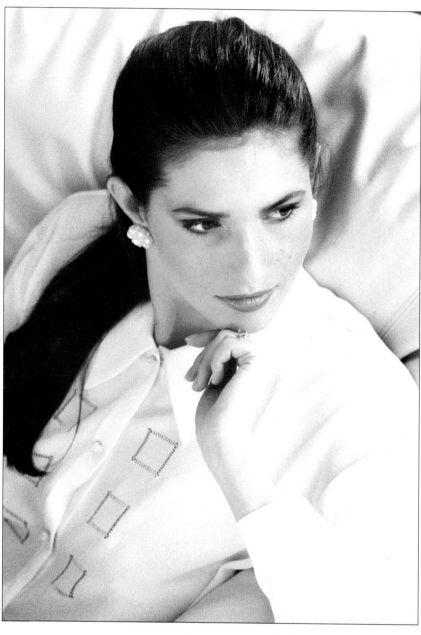

▲ For this shot Mike asked Jo to sit down on the couch and moved it until she was far enough away from the windows to turn her whole face towards the light. From the top of a stepladder, he shot downwards to produce a thoughtful and original portrait. A golden reflector lying against the base of the ladder has given the image a warm and flattering look.

The set up

David and Mike were working in a rectangular sitting room. There were three large windows in its long east facing wall, and these were the only natural light sources. David worked very close to the window and used no reflectors. Mike tried out various chairs and couches before he decided on a position in which Jo looked comfortable.

The day began fairly sunny, but soon became overcast and gloomy. Mike used a set of golden reflectors to counteract this. For his last shots he balanced one reflector in front of her and placed a bigger one on her right to even up the light on her face.

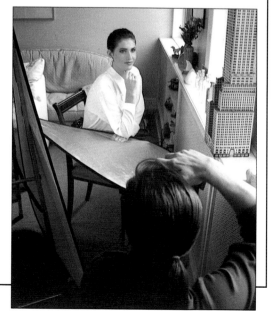

But the lighting wasn't so successful. Because the right hand side of her face was directly facing the window, it looked far too bright in the final image, while the left side was a lot darker. Overall there was too much uncontrolled bright light in the picture.

Controlling daylight

Mike's first shot was similar to mine, with Jo sitting sideways and looking directly into the camera. He also used a Nikon F3. But there the similarity ended. He chose a 105mm lens and ISO 800 film, which is fast enough to cope with low light. This allowed him to pull down the window blind, which cut out the strong light and added more contrast to the shot.

He tried seating Jo in several different chairs and moved her around the room to find the best light. He even tried standing on a ladder and shooting down on her from above. As the day went on it grew gloomier, so he used golden reflectors to make use of what light there was, and faster film to increase the grain.

Kinder than flash

'If you use natural light carefully you'll find that it's far kinder than flash is. It causes none of those hard shadows, and this gentle quality is excellent for revealing the shape and form of faces, especially if the light comes exclusively from one side.

'If you're dealing with direct sunlight, a sheet of tracing paper will make the light much softer. A thin blind will do just as well, as we proved today.' Other options are a white cotton sheet or a net curtain.

WORKING WITH DAYLIGHT

▲ *There's nothing wrong with David's composition here. He's taken a fine portrait of a natural and relaxed-looking model. But his lighting has really let him down, as Mike explains. 'It was sunny when David started shooting, and Jo was very close to the window. The result was a washed out shot with too much light and not enough contrast. He should either have moved her further away from the window or used a blind to diffuse the light.'*

1 DIFFUSING LIGHT
Mike's first shot was similar to David's, but he diffused the bright sunlight by pulling down a pale blind. He used a fast film (ISO 800) to cope with the low light and a reflector to bounce light back on to the left side of her face. The resulting light brought out Jo's natural skin tone, but there was too much shadow on her left side.

2 A SOFTER LOOK
Mike switched to ISO 1600 film for this portrait, to increase the grain. He stretched a piece of black stocking over his lens to get an even softer feel. Then he zoomed in for a head and shoulders shot. Jo was sitting on a chair further away from the window, which changed the background but made the light less intense and easier to control.

3 THE GOLDEN TOUCH
Jo moved to the couch for this shot to get a better background. To capitalize on the worsening light, Mike abandoned the homemade filter and used two golden reflectors. They gave the image a warm and even light. He wanted to change Jo's look so he wrapped a black shawl around her, asked her to sit forward on the couch and shot from just above her.

Tip — Using window light

The biggest problem with window light is that it falls off across the picture. So getting even light can be difficult, as Mike describes. 'The fall off is worse the nearer you are to the window. But if you move too far away you don't have enough light – it's a question of finding the right balance. Reflectors are a big help, though. They can even up the light hitting a face however close the source is.'

SLR tip

To enhance grain with transparency film, try changing the processing. Load a roll of ISO 400 film and then set your camera's shutter speed dial to 1600, a technique called pushing. Then, when you process the film, ask for push processing and specify a two stop push. This way you'll usually get more grain than by simply using ISO 1600 film. It's handy because 1600 isn't always easy to find.

Compact tip

Many compact cameras can't take film faster than ISO 400, and so you can't use them to produce the grainy effects similar to those in Mike's pictures. You can get around the problem by fitting a neutral density (grey) filter over the lens, making sure it doesn't cover the exposure sensor. This will let you imitate faster film. To imitate ISO 1600 film on a compact, choose a Kodak Wratten ND 0.6 filter.

4 THE EYES HAVE IT

When Jo draped a shawl over her head, Mike knew this was the shot he wanted. He asked her to rest her chin on her hand and then shot at close range from slightly above. A slower shutter speed lightened the skin tones very effectively. This emphasized the colour in Jo's eyes and made the image look like a fashion shot.

Male portrait

You don't always need reflectors, and indeed for a portrait of a man, you may do better without.

1 Expression

The expression on your model's face all depends on the mood of the shot and the model himself. Try talking to him with the aim of producing different reactions. Keeping your subject occupied ensures that he doesn't look bored and makes for better shots.

For attention grabbing portraits, you could ask your model to look directly into the lens. His face doesn't necessarily have to be full on to the camera.

This means that when you glance at the photograph, you establish eye contact with the subject immediately.

▼ *Successful pictures can certainly be shot in bright sunlight, as this image proves. The wall provides a texture to contrast with the smoothness of the model's clothing.*

2 Background

Outside, for a simple and effective background that's easy to find, just ask your subject to sit or stand in front of a wall.

Rough, exposed stone adds a contrasting texture to the shot, while smooth, painted walls add colour. If the background is very dark or pale, take an incident light reading or measure light reflected from a photographic grey card.

▲ *Off-centre framing and a combination of bright colours make for an eyecatching portrait.*

3 Clothing

What your model wears has a large bearing on the final feel of the photograph. With a younger man, for a classic, rugged feel, dress him in denims or a leather jacket, and add sunglasses for the finishing touch.

Other clothing for the same effect includes checked shirts, white T-shirts and heavy boots. Clothes that have been worn in, rather than looking brand new, are often more effective for this type of shot.

For a more formal feel, what about dress shirts, colourful ties and well polished shoes? Remember that your model should feel comfortable in whatever clothes he's wearing, so it's a good idea if he wears his own garments.

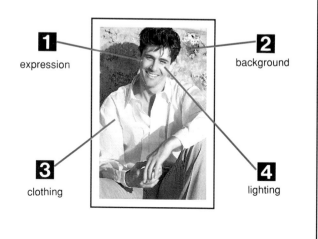

1 expression
2 background
3 clothing
4 lighting

4 Lighting

Men's faces photograph well when sidelit, and strong shadows – even on the face – often add to the shot's appeal. This means that you can turn contrasty lighting to your advantage.

Aim to emphasize facial lines if you want a shot that's full of character. It's not a disaster if your subject narrows his eyes because of the sun – you'll be able to see more expression in his face.

With a male subject, midday sunlight is not

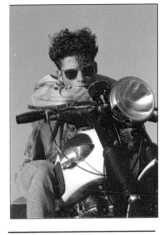

▶ *A prized motorbike makes an ideal prop here. The rugged image is reinforced by the faded denims and sunglasses.*

necessarily unflattering. Try positioning your model so that one side of his face is plunged into shadow.

Indoors, create the same effect by placing a light to one side of your subject. Take several shots with the light in slightly different positions, then see which works best.

5 Mood

When capturing men on film, many photographers choose to aim for a realistic portrait. So, soft focus filters are out and anything that enhances the realism is in.

Black and white film is a good choice for this. Slow versions can record every pore and line of your subject's face – and good printing can maximize the effect.

▼ *Black and white film, a fairly narrow depth of field and an intentional darkening of the picture edges concentrate your attention on the man's face.*

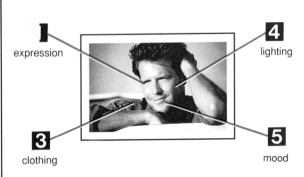

1 expression **4** lighting

3 clothing **5** mood

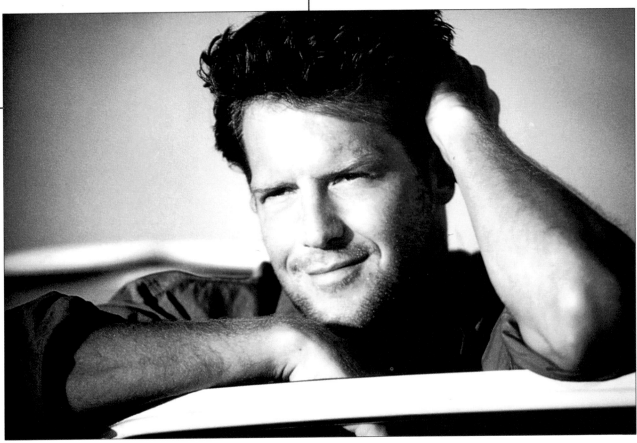

George Wright – Portraits with flash

George Wright's portraits have a very distinctive style. He likes to photograph his subjects outdoors using flash to separate them from their environment – an approach that anyone can try.

Wherever he goes, George Wright always brings a camera with him. 'The best shots are often the ones you come across unexpectedly', he says. 'Taking advantage of those situations isn't always easy, but that's what makes it interesting. Strangers usually don't mind posing – they're often flattered, and only too happy to co-operate.'

Wright often uses flash to light his outdoor subjects. 'I like the unexpected quality it gives to a photograph', he explains. 'You always stand a chance of ending up with something interesting, but you can never be sure. I like the way the artificial light separates the subject from the surrounding daylit environment. A lot of photographers now use this technique because it can make a simple portrait look very dramatic.'

Most of Wright's work over the last 20 years has been commissioned by newspaper magazines and Sunday supplements. He sold his first portraits to the *Observer* back in the early '70s and they're still one of his biggest employers. Much of his work is done together with feature ideas, so he's often expected to sum up the theme of a whole article in a single photograph.

Take his portrait of a man surrounded by shrubbery on page 24. The photo was commissioned by the *Observer* for an article on weed control in gardens, so Wright composed a shot showing an unhappy gardener besieged by unwanted greenery. The picture sums up the feature's theme perfectly, and flashlighting the foreground really adds to the impact.

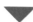

"For this portrait I decided to photograph Scottish fisherman Jimmy McNab in his natural environment; so he stood on a rock at the edge of a lake holding his catch aloft. The sky behind him was very dark, so I knew that lighting the subject with flash would make him stand out in the foreground."
Taken on a Bronica ETRSi with an 80mm lens, Fuji ISO 100 roll film and flash at f8 .

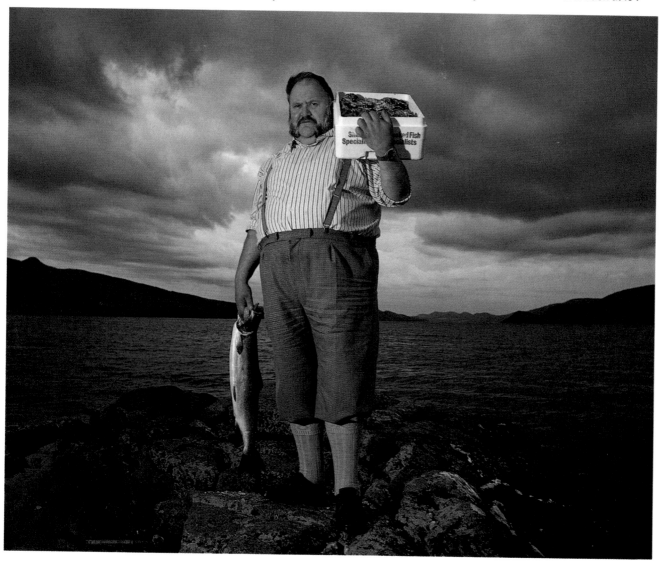

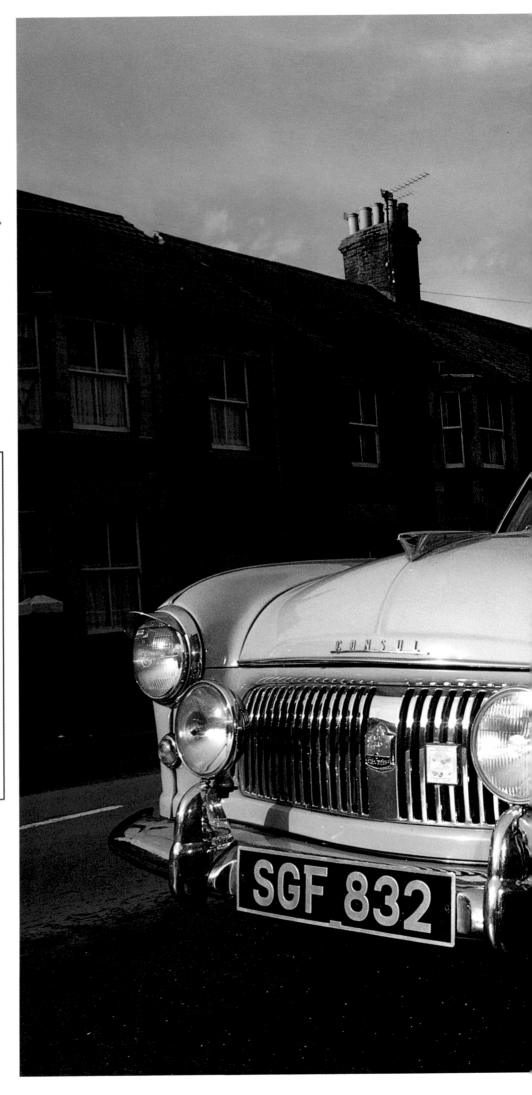

"I came across this shot completely by accident. I was driving along one morning when I saw this bloke polishing his beloved Ford Consul. So I jumped out and set up as quickly as I could. Even though the day was bright, I used hand-held flash to make him stand out from the shadows behind."

Taken on a Bronica ETRSi with an 80mm lens, Fuji ISO 100 roll film at f8 and 1/100th sec.

You can do it

Flash can be very useful when shooting outdoors in colour. It's most helpful when conditions are difficult, because it gives you greater control over the shot. By lighting the foreground with flash you can eliminate background colour and shift the emphasis on to your subject.

George Wright uses a 660 watt/second Lumedyne flash system for lighting large areas, and Metz guns for smaller work. But an ordinary flash gun can also be extremely effective.

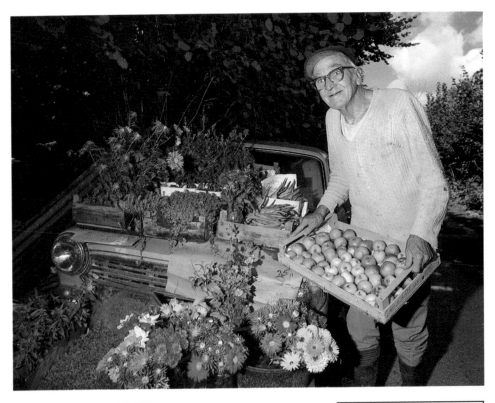

"This was another one of those situations where I came across a man by the roadside putting his produce on the bonnet of his car. Something about him made me want to stop and take his photograph, and he turned out to be an amazing chap, full of character. He was standing in a heavily shaded area, so I used flash to make sure I got him."

Taken on a Bronica ETRSi with a 50mm lens, Fuji ISO 100 roll film at f8 and 1/60th sec.

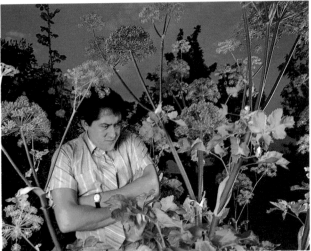

"I was looking for a shot that would convey the idea of a garden overrun with weeds. I asked the gardener to stand in the middle of this spectacular group of plants, and arranged the shot so it looked as if he was being pushed out of his own garden. Again I lit the foreground heavily with flash, throwing the background into shade."

Taken on a Bronica ETRSi with an 80mm lens, Fuji ISO 100 roll film at f8 and 1/60th sec.

Technical details

George Wright always shoots off a Polaroid if he has enough time. 'When you're using flash outdoors, you really have no idea what the shot will look like, and a Polaroid reduces the risk of total failure.

'I just don't trust myself to get the exposure right every time, so I find instant pictures an enormous help.'

"This portrait of Julie Christie was done as part of a Sunday magazine idea about people's obsessions. Her obsession is apparently ducks and geese, so I went to her home and set up this shot of her and a bird. Julie was a very relaxed subject, probably because she's so used to being photographed. I used my Lumedyne system to light up the whole kitchen, and a wider lens than usual to get it all in."

Taken on a Bronica ETRSi with a 50mm lens (80mm is the standard lens size on medium format), Fuji ISO 100 roll film and flash at f8 and 1/30th sec.

Tobi Corney – Celebrity portraits

"I set up this shot of actors Steven Fry and Hugh Laurie on a film set at Pinewood Studios near London. I took my own background and borrowed the Art Deco chair from the set.

The main light was fired through a large softbox on the left. It lit both actors and the background. I used another flash unit, fired through a small softbox, as a back light. This light was more powerful than the front light, so that it picked out the actors from the background."
Taken on a Hasselblad 500CM, 80mm/f2.8 lens at f22 and Kodak Ektachrome EPR slide film ISO 64. Lit with two Elinchrom studio flash units.

Tobi Corney specializes in photographing stars... of the music world and the silver screen. Through creative use of props, simple lighting techniques and a willingness to experiment, he produces unique portraits that powerfully characterize his subjects.

Portrait photographer Tobi Corney is never stuck for interesting subjects to shoot. He spends most of his time dashing between video shoots and film sets, photographing well known musicians, actors and actresses. Recently, he's started to photograph captains of industry for company brochures and magazine articles. 'I find businessmen are more of a challenge, because they're not used to being photographed; whereas publicity shots are part of an entertainer's working life,' he explains.

Pushed for time
Tobi's work is notable for his creative use of props. 'No matter how pretty or interesting a person's face, a straight shot often doesn't tell you much about them,' he points out. 'I use props like picture captions – to explain something about the person in the picture.'

The biggest challenge when photographing showbiz celebrities is lack of time – Tobi is rarely given more than five minutes with his subjects. This means that he has to find out as much as possible about them beforehand, so he can plan pictures in advance.

Well equipped

He also has to have total confidence in his equipment and lighting techniques. 'When it comes to equipment I need reliable cameras that aren't going to break down. I also need the best quality lenses available. For me, that adds up to Nikon equipment for 35mm photography and a Hasselblad system for shooting medium format.'

Tobi's favourite piece of equipment is the Nikon 105mm f2.5 lens that fits his Nikon F3 cameras. 'I enjoy shooting on the 35mm format because it's so quick to use and it lets me work spontaneously. There's also a wide range of specialist lenses for my Nikon cameras, and the smaller format lends itself to grainy shots,' says Tobi.

Most of his shots are lit by portable Elinchrom studio flash packs and heads. These are set up before the subject arrives to save time during a shoot. According to Tobi, the advantage of flash is that it is reliable and controllable. He tries to keep lighting simple, as he explains: 'If you use complicated lighting set-ups your shots often look overworked. At the end of the day a simply lit photograph looks better than an overlit shot.'

Technical details

Processing slide film through the C41 (print film) process gives negatives which show colour shifts in the shadow areas. Different brands of film give different colours – Fuji slide films turn shadows green, Kodak films turn them yellow and Agfa films turn them purple. The film's contrast is also increased, which helps to 'clean up' white backgrounds.

Alternatively, you can try processing print film through the E6 (slide film) process. This gives you slides that also show colour shifts. This technique is more suited to portraits, because of the interesting skin tones it produces.

'I only mix processes when I want a certain effect and I always know the effect I will get,' says Tobi. 'There's no point messing about with processes if you're just keeping your fingers crossed that the effect will make the shot more interesting.'

If you want to try this technique for yourself, you'll need to find a professional lab that's willing to mix processes. Also, be prepared to spend plenty of time and film experimenting if you want to learn how to predict your results.

"This is a portrait of John Giblin, a session musician and ex-bass guitarist with rock group, Simple Minds. The instrument is John's electric stand up double bass.

The picture is made up of two separate exposures shot on the same piece of film. I took the double bass using a Nikon fisheye lens positioned a few centimetres from the strings. This is why the image is so distorted. I posed John so that his ear echoed the shape of the bass."
Shot on a Nikon F3, 15mm/f3.5 full frame fisheye and 105mm/f2.5 lenses and Ilford FP4 ISO 125 print film. The aperture was f22 on both exposures. Lit with Elinchrom studio flash.

"I took this shot of pianist Peter Donohoe for the cover of an album of piano concertos.

Peter has quite a strong profile so I used backlighting and photographed him in silhouette. This always gives a strong image. The green tint in the shadow areas is a result of processing slide film in print film chemicals."
Photographed on a Hasselblad 500CM, 150mm/f4 lens at f22 and Fujichrome ISO 100 slide film. Lit with Elinchrom and Broncolor studio flash units.

"David Trott is an advertising guru who is responsible for the ideas behind many of the major advertising campaigns. There weren't any obvious props to use, so I tried to portray him as 'very knowing'. The idea is that he knows something you don't. I used a single flash head from above and to one side, and shot against black velvet."
Taken with a Hasselblad 500CM, 150mm/f4 lens at f22, on Ilford FP4 ISO 125 print film. Lit with a single Elinchrom studio flash unit.

"This is a portrait of Chris, my background painter. I wanted the background of the shot to look like block colours in a painting, and to record his face as a photographic print.

I took the black and white photograph especially, and then took the colour shot with Chris holding the black and white print in place. I chose a long lens and a wide aperture to throw everything except his hand and the print out of focus."

Shot on a Hasselblad 500CM, 150mm/f4 lens at f8 and Ektachrome EPR ISO 64 slide film. Lit with Elinchrom studio flash units. Black and white portrait taken on a Nikon F3, 105mm/f2.5 lens at f8 and Ilford FP4 ISO 125 print film. Lit with Elinchrom studio flash units.

You can do it

Stunning portraits are possible with a minimum amount of equipment. On his professional assignments Tobi often uses a 35mm camera and 105mm portrait lens, a single light and a piece of black velvet as a background. 'If you only have one light it's sensible to shoot against black velvet, because it does away with the need for any background lighting. It also focuses attention on your subject,' he says.

'White backgrounds look good, but they need careful lighting to keep them looking clean. Also, powerful lights fired on to a reflective white background can cause flare, so you need plenty of space between your subject and the background. This may not be possible if you're shooting in a small area like an office or your own living room.'

"This picture, for the cover of a record album, was taken on Polagraph – Polaroid's 35mm instant slide film. It's a high contrast film with a nice grainy feel, making it ideal for this rather 'bluesy' portrait.

The musician in the picture is saxophonist, Tommy Smith and the reason he's looking through the hole in the sax is because the album is called 'Peeping Tom'."

Taken on a Nikon F3, 105mm/f2.5 at f22 and Polaroid Polagraph ISO 400 slide film. Lit with Elinchrom studio flash.

A black and white portrait

A black and white portrait of Tommy Smith by Tobi Corney shows how the masters use monochrome. Louisa Somerville takes a Masterclass from Kim Furrokh to learn how.

Arriving at Kim's studio, I thought that taking a good portrait would be quite easy. Yet, even with the advantages of Sarah, a professional model, and a fully equipped studio I found that first class results required more than enthusiasm and a moderate photographic talent.

I started shooting, using a Nikon FE2 with a 50mm lens and Kodak Plus X ISO 125 black and white film. Lighting was a problem from the start – the main light shone directly at Sarah and I used a second one with a diffusion screen to light the background. But I couldn't get rid of the harsh shadows cast by the main light. I tried moving in to eliminate them, but ended up cropping too close to Sarah's elbow.

Forward planning

When Kim took over he chatted to Sarah, then asked her to change into a white blouse. 'Talking to your model is very important,' he says, 'because a portrait is about an individual. Look closely at her features and think about how you're going to use them in the shot. You

▲ *Kim Furrokh is a professional fashion and portrait photographer.*

▼ *To get a relaxed, informal portrait like this, you must make your model feel at ease. Encourage her to try out a variety of subtle changes in her pose and expression – that way you'll end up with a picture to please both of you.*

The set up

Louisa used two tungsten lights, one with a diffusion screen. She chose blue background paper. When Kim took over, he switched to white background paper. He used three lights: one soft main light on the model, a second light for the background and a third light behind the hair to give it a glow.

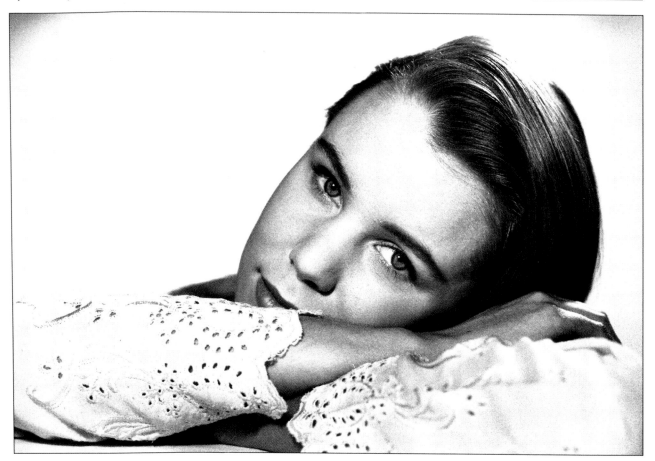

▲ In Louisa's first shot, the conflicting angles of the model's legs, chair legs and shadows add up to a confused composition. An ugly shadow runs down the model's neck, too.

▲ In this close-up shot, the lighting works better but there is too much empty space and the image is cropped unflatteringly below the bust, so Sarah's arm appears to be severed.

Tip — Soften the effect

When photographing women you usually want the skin to look soft without much detail. You can use a soft focus filter to spread the highlights – but with a filter on the lens you can't get rid of the soft focus effect.

Better still, if you do your own printing, use a stocking or soft focus filter on the enlarger. This way shadows instead of highlights are spread and you can control the diffusion.

should have an idea of the pose you want before your model arrives so she will feel as comfortable as possible. Get someone to stand in while you set up the lighting, so you need only make minor adjustments with the model there. That way she'll feel more at ease.' The same rules apply whether you're at home photographing a friend or in a studio with a professional model.

Kim decided to move in for a close-up shot that focused on Sarah's lively eyes. However, he didn't just want to photograph her head: 'Sometimes it's a good idea to get the hands in the picture and use them to frame the image,' he says. He used trace to soften the main light and added a light for the hair. A black reflector to one side put shadow on her face, to aid modelling.

Kim used the same film and camera but changed to an 85mm lens. 'I didn't use too long a lens because I wanted to be able to talk to the model,' he explains. 'A wider angle lens would have given too much background.'

Kim used a fast shutter speed so that he could set a wide aperture, in order to narrow the depth of field. This helped to draw attention to Sarah's eyes. 'Always concentrate on the eyes when you're taking a portrait,' he says.

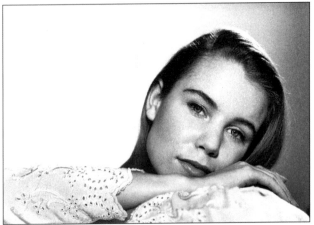

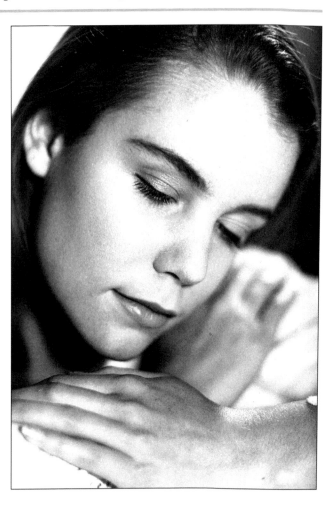

1 A FRESH LOOK
Because he wanted to shoot white on white, Kim asked Sarah to change into a white blouse and replaced the blue background paper with white. 'I want her to look light and fresh, to convey her youthfulness,' he said. The white cloth Sarah leaned on reflected light into her face and brought out the intricate detail and texture of the embroidery on the sleeve.

2 CLOSE AND CANDID
Kim asked Sarah to cross her hands to frame her face more closely in an innocent pose. He moved closer for a shot of her gazing down, and produced this reflective portrait. The right hand side of her face is sharply focused, clearly showing the texture of her skin. The rest of her face and her arms are thrown out of focus, framing the image softly.

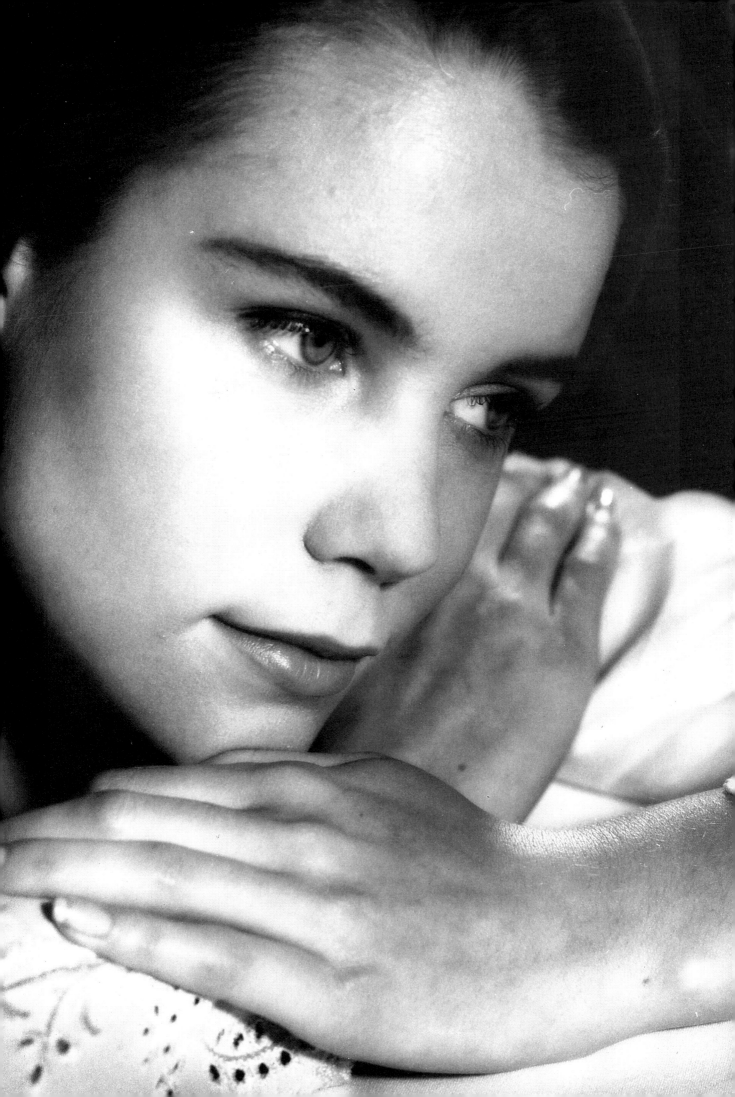

3 SOFTENING UP (PREVIOUS PAGE)

Kim changed the look of the final picture during printing – a flexibility that shooting in black and white gives. He put a stocking on the enlarger to diffuse the shadows. The result is soft modelling on the cheeks without showing the skin's pores, and the hair has a rich, glossy tone without white highlights. Kim also burnt in areas at the top of the print to darken the background.

▼ ► *Kim decided to try a different look. By this time, despite the lights, Sarah was feeling cold, so he asked her to wrap herself in a furry coat and switched to a dark background. The result was a playful pose with plenty of movement, like a fashion shot.*

Black and white gives the picture a dramatic feel – the emphasis is on shape and form, without the distraction of colour.

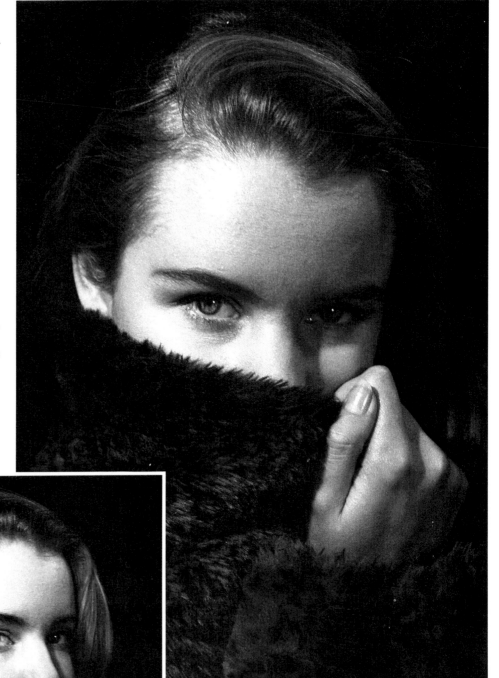

 Compact tip

❏ Framing a tightly cropped portrait can be hit and miss with a compact because of viewfinder inaccuracies. To get the composition perfect, frame the subject loosely when you take the picture, then fine tune the cropping by trimming the print.

 SLR tip

❏ To get the pale flesh tones reminiscent of Hollywood studio film star portraits, fit a deep red filter over the lens. This closely imitates the lack of red sensitivity typical of the early films used for still and movie photography.

Portrait with props

When you're photographing people, careful use of props can turn an ordinary picture into a successful portrait. Tobi Corney shows Bill Bradshaw how it's done.

◀ *Tobi Corney is a professional portrait photographer who specializes in photographing actors and actresses, musicians, entertainers and leading figures in industry and commerce.*

To take a really outstanding portrait you need to record more than your subject's looks. Instead, you should aim to shoot a picture that tells you something about the person behind the face. A good way of doing this is to use a relevant prop. This acts as a visual clue and can reveal as much about a person as their facial expressions.

Rap snap

I went along to Tobi's studio to try my hand at photographing an up-

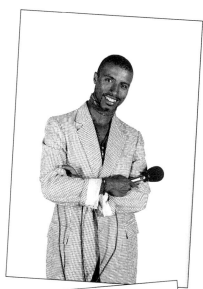

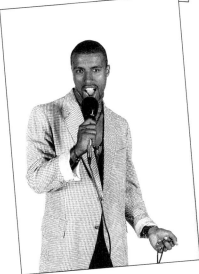

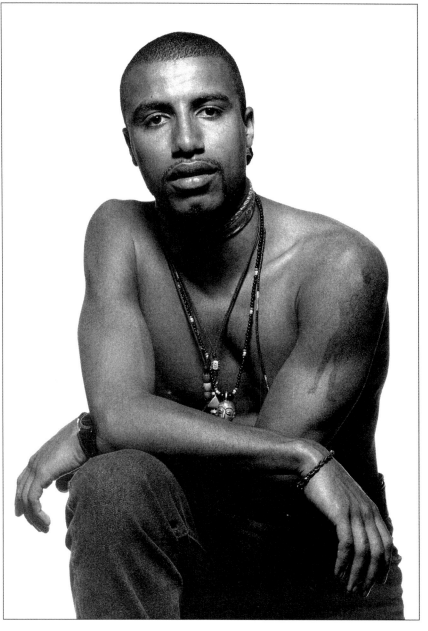

◀ *The lighting on Bill's pictures is flat, which doesn't really suit ADJ's tough image. The poses look forced, especially on the 'performance' shot, and fail to reflect ADJ's true character. While they are technically competent Bill's photographs are hardly successful portraits.*

1 ▲ GETTING THE LIGHT RIGHT
For his first shot, Tobi asked ADJ to remove his jacket and chose to shoot from a low viewpoint to make him look more dominating. He also changed the lighting set up to give a harder, more directional light. As a final touch he gave ADJ a box to stand on. This helped him strike a more interesting pose.

and-coming musician – rap artist, ADJ. The idea was to take a portrait that sums up the image of a young rapper.

Having chatted briefly to ADJ, I was eager to get started. I set up two flash units aimed into white umbrellas, one on either side of him. Tobi's Nikon F3 was already loaded with Agfapan APX 100 black and white film, so I fitted a 50mm lens and started snapping.

I asked ADJ to hold a microphone, to draw attention to the fact that he is a singer. But after half a roll of film I realized the image looked bland and said little about him as a person. I tried to liven up the shot by asking him to pose with the mic as though he was performing. This was an improvement, but it still didn't capture ADJ's character.

Tobi's turn

I handed over to Tobi and watched him go to work. The first thing he did was change the lighting – choosing a small softbox as a main light. Then he set up a large black polystyrene board on either side of ADJ and moved the two umbrellas backwards to light the background.

Next, Tobi asked ADJ to remove his jacket and change his pose for a bolder look. He fitted a 105mm lens, which gives a more flattering perspective, and began shooting. The overall look of the shot was much closer to ADJ's image than either of my attempts.

The next step was to add a prop. Tobi asked ADJ to don the top hat he'd brought. This changed the whole feel of the portrait. Already,

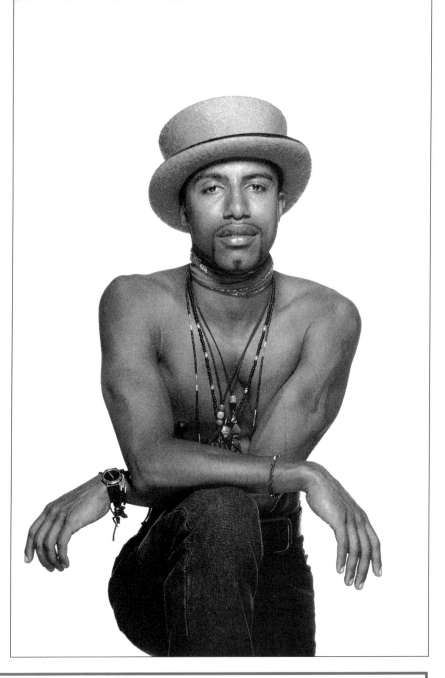

The set up

Tobi used an Elinchrom studio flash head fired through a small softbox as his main light. This was positioned high above and in front of ADJ. The exposure for the main light was f16.5 at 1/60th sec. He used a white reflector in front of and below ADJ to lighten the shadows on his face. A large black polystyrene board either side of ADJ added tone to his outline and picked him off the background. The white paper background was lit by two Elinchrom studio flash heads fired into white umbrellas. They were set to give a half stop extra exposure. This made sure the background was recorded as a clean white, but wasn't bright enough to cause flare around ADJ. Tobi helped ADJ create an interesting pose by giving him a box to rest his right foot on. He hand held his Nikon F3 and 105mm lens to begin with, but mounted the camera on a tripod for the final shots.

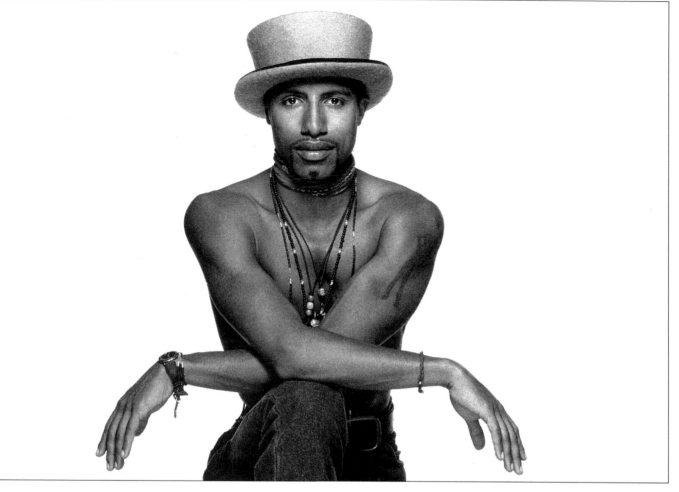

2 ◄ ADDING A PROP
Tobi asked ADJ to wear the top hat he had brought with him. The prop adds interest and gives a pointer to ADJ's character. He also told him to straighten his pose and spread his arms to the sides to improve the composition. A white reflector in front of and below ADJ lightened the shadows under his chin and the rim of his hat.

3 ▲ EXAGGERATING THE POSE
To accentuate the shape of the shot and to add a sense of space, Tobi asked ADJ to exaggerate the spread of his arms and then switched to a horizontal format. He paid a lot of attention to the exact positioning of ADJ's arms, making sure they looked relaxed. This fine-tuning makes the difference between a good shot and an excellent portrait.

Tip

Square eyes

'Eye contact is vitally important for a good portrait, so it's necessary to pay close attention to the way you light your subject's eyes', says Tobi. 'Try using a square softbox instead of an umbrella – it gives a more attractive catchlight.'

ADJ's distinct style was beginning to show through.

Before taking the shot, Tobi positioned a white reflector in front of and below ADJ to bounce light back into the shadows under his chin and the rim of his hat. Then he began rattling through films at a fast rate, sensing that the picture was coming together.

Changing the format

Even so, he was sure he could improve on the picture. He directed ADJ to exaggerate his pose by stretching his arms out further to the sides. This changed the shape of the picture, so Tobi moved the black poly boards outwards and switched to the horizontal format. 'Although you think of a portrait as vertical, don't be afraid to try a horizontal format if it suits the shape of the shot', he commented.

Tobi felt the portrait was lacking something, so he decided to add the microphone as a second prop. 'The mic tells you that ADJ is a singer, rather than just a stylish young man', he pointed out.

He told ADJ to hold the mic in his right hand, but this looked rather uninspiring. So he tried experimenting with the lead in an attempt to come up with an interesting composition. Finally, Tobi found the shot he'd been searching for, but he had one final improvement in mind: despite the creative use of props there was still something missing – ADJ's expression wasn't right. 'I want a harder look that conveys ADJ's 'streetwise' attitude', he explained.

Tobi continued shooting, talking non-stop to ADJ, until he felt confident he had the picture he was after – a portrait of a young rapper that's full of attitude!

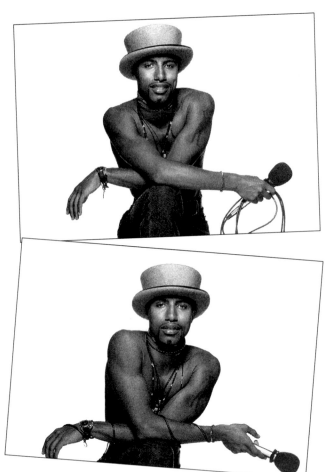

4 ◀▼ TOBI TAKES THE LEAD

Tobi was happy with the shape of the shot, so he locked his camera into position on a tripod. He then added a microphone as a second prop. The challenge was to use this prop creatively. Tobi tried several combinations, starting with ADJ just holding the mic. He then wrapped the lead round ADJ's arms. This added to the impact of the shot. Finally he asked ADJ to hold the coiled lead in his other hand. This combination gave the most balanced shot.

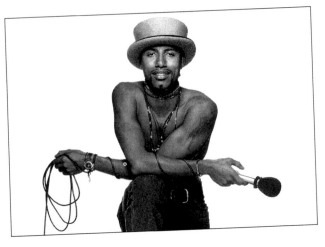

5 ▼ RAPPING IT UP

With the lighting, pose and props how he wanted them, Tobi was looking to capture a certain look – or 'attitude'. This was the special ingredient that would sum up ADJ's image at a glance. To help him act naturally, Tobi played one of ADJ's own records. This did the trick – ADJ 'came alive' and Tobi grabbed the shot he'd been after.

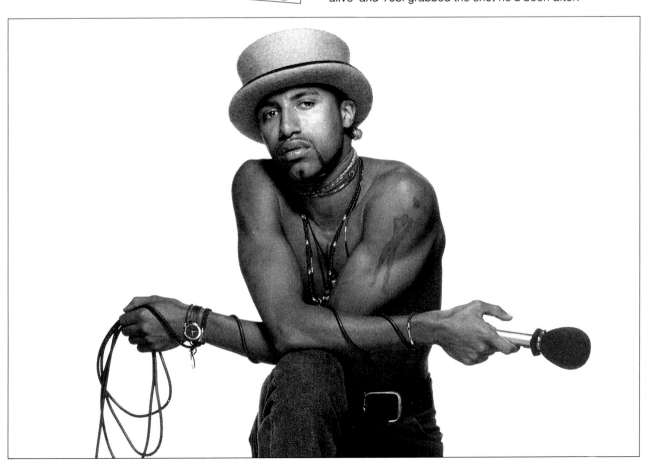

An environmental portrait

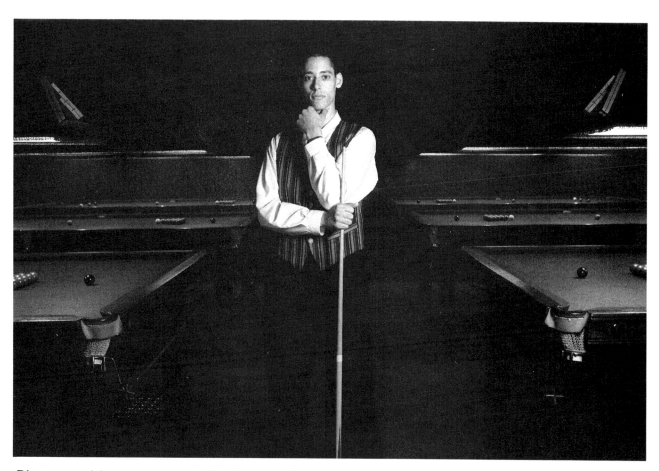

Photographing a person in their natural surroundings can add a new dimension to your portraits. Tobi Corney shows Bill Bradshaw how it's done.

A portrait which shows your subject in his or her surroundings is known as an environmental portrait. The skill, as far as the photographer is concerned, is to use the setting creatively, so it adds to the shot and tells you something extra about your subject.

I asked portrait photographer Tobi Corney to show me how to tackle this type of shot. He suggested going along to a local snooker club to photograph the club's star player, Matt White.

'Photographing Matt against the backdrop of the snooker hall should help us capture some of the atmosphere surrounding a professional snooker player at work', he explained.

When we arrived, Matt was busy potting balls on one of the end tables. Being naturally impatient, I decided to start straight away. I borrowed a Nikon F3 camera and a large Metz flashgun and asked Matt to pose in front of a scoreboard.

▲ For this shot, Tobi fitted a 35mm lens on to his Nikon F3. This gave a wide angle of view that takes in the rows of tables in the background. He reinforced the picture's symmetrical composition by placing Matt in the middle of the frame. Tobi was careful to balance the brightness of his main light with the table lights, so that the correct exposure for Matt also recorded the background details.

▲ ▶ Bill stood Matt in front of one of the scoreboards for his first shot. Unfortunately, reflections from the shiny wood and metalwork spoil the picture. On Tobi's advice he moved Matt to one of the tables. This is an improvement, but the flash kills the atmosphere of the shot. In the gloom of the snooker hall, Bill didn't notice the wooden triangle sticking out from behind Matt's ear.

GOING FOR ATMOSPHERE

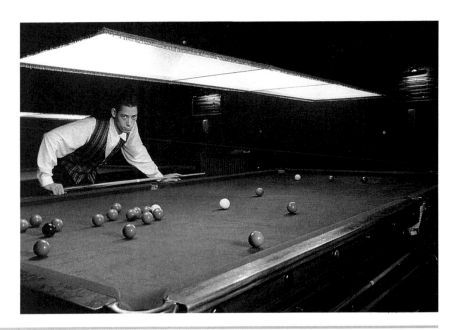

1 ▶ TABLE LIGHTS

Tobi asked Matt to lean over the edge of one of the tables, and used a 35mm lens to frame a wide view. This allowed him to take in the table lights and the scoreboards on the wall. These details help to conjure up the atmosphere of a dimly lit snooker hall. He lit the shot using just the overhead table lights. These gave an exposure of 1/8th sec at f8, so a tripod was essential to avoid camera shake.

The set up

Bill used a 50mm lens on a Nikon F3 body, which he loaded with Agfapan APX ISO 100 black and white film. He lit Matt with a Metz 45 CT5 flashgun, on automatic.

Tobi also used a Nikon F3, but switched between a 35mm and a 105mm lens. He used Fuji Neopan ISO 400 film, but uprated it to ISO 800 to increase the graininess of the pictures. Uprating the film also allowed him to set small apertures – so the depth of field wasn't too narrow.

He lit his shots using the tungsten modelling bulb in an Elinchrom studio flash head, and softened the light by fitting a small, square softbox.

Tobi used a silver reflector on the opening shot to bounce light into the shadows on Matt's face.

Good advice

I was happily snapping away when I looked up and happened to notice Tobi's rather doubtful expression. He very politely suggested that moving Matt over to one of the snooker tables might give me a more interesting picture. I gratefully accepted his advice and also switched to a lower viewpoint in an attempt to make my pictures look more dramatic.

By now Tobi was ready to begin. He loaded up with Fuji Neopan ISO 400 black and white film, and uprated it one stop to ISO 800 for added graininess. 'I think a grainy image will suit the low lit, slightly seedy feel of the snooker hall', he commented.

For his first shot Tobi asked Matt to stand halfway down the middle aisle, between the rows of tables.

This gave a pleasing symmetrical composition. Tobi opted for tungsten lighting, rather than flash, to retain the atmosphere of the snooker hall and lit Matt with a single unit from the side. The brightness of this light was adjusted so that it was balanced with the table lights in the background.

Playing for real

Next, he decided that a less posed shot was a good idea. So he moved Matt over to one of the tables. Using a slow shutter speed, he was able to light Matt using just the overhead table lights.

Although the picture has bags of atmosphere, Tobi wasn't satisfied. He wanted a portrait that shows Matt *playing* snooker, so he asked him to play a few shots.

After Tobi had taken a couple of frames, Matt picked up a bridge cue for a difficult shot into the bottom pocket. Tobi sensed a perfect photo opportunity and moved closer to the table. He asked Matt to play the shot slowly and managed to time the exposure to perfection – capturing the ball just as it was about to disappear into the pocket.

Breaking up

By this time Tobi was in full swing, racing around the table, sizing up the angles and looking for the perfect picture. He asked Matt to move to the end of the table and blast the cue ball into the pack of

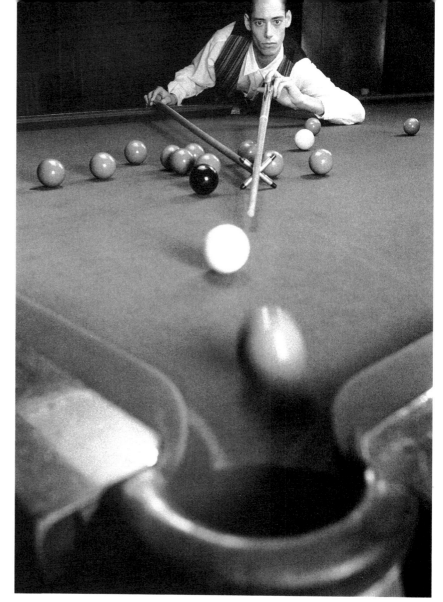

2 PLAYING A SHOT

The next step was to show Matt playing a shot, which meant he had to move out from beneath the table lights and into shadow. Tobi positioned his main light slightly above the camera and pointing directly at Matt. He attached two barndoors to the soft box to control the beam of light, so that it lit Matt and not the table or the balls. This lighting set up let Tobi select an aperture of f8 and a shutter speed of 1/15th sec – which was slow enough to blur the moving ball. His final touch was to create a more dramatic composition by moving in close to the table and filling the foreground with the bottom pocket.

3 DIRECTING ATTENTION

Tobi decided to go back to the original landscape format and crop in closer on Matt's face, so he fitted a 105mm lens and shot down the length of the table as Matt broke off. He moved the main light to the end of the table so it was pointing at Matt. This gave an exposure of 1/15th sec at f5.6. The wider aperture, together with the longer focal length lens, reduced the depth of field – so the balls in the foreground were thrown well out of focus. This directs attention towards the intense concentration on Matt's face.

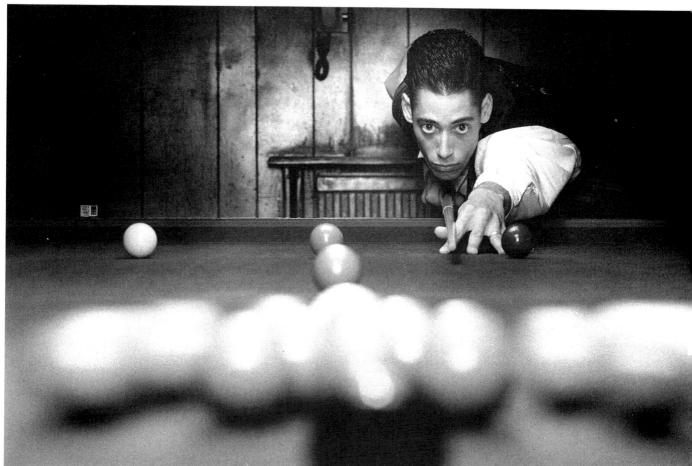

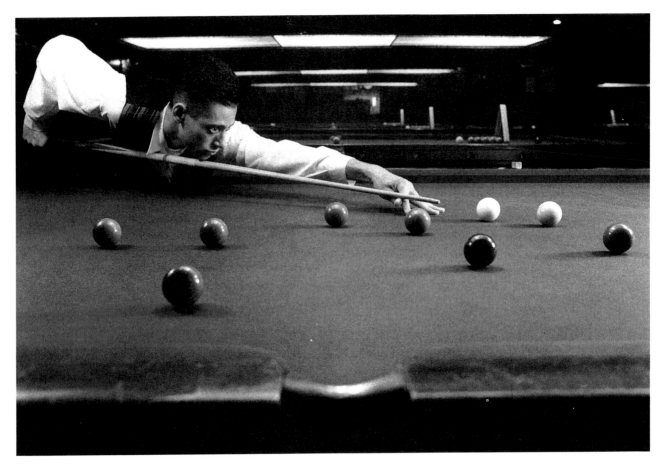

reds. 'If I can time this right I should be able to take the shot as the cue ball splits the pack', he suggested.

Motor powered

To increase his chances of grabbing the decisive moment, Tobi attached a motordrive to the camera. This let him shoot off two or three frames in quick succession. Even so he had to ask Matt to break several times, resetting the pack after each shot.

Totally impressed with Tobi's efforts I was ready to call it a day, but he had other ideas. 'The only problem with this set up is that you

lose some of the atmosphere of the snooker hall – Matt's surroundings aren't really adding to the shot', he pointed out.

In a flash, Tobi moved around so that he could photograph Matt from across the table. This viewpoint let him include the rows of snooker tables in the background. The table lights enhance the picture by breaking up the dark areas at the back of the hall.

Having tried several different compositions, Tobi settled on a dynamic three quarter view of Matt leaning across the table, about to play a shot.

4 ADDING ATMOSPHERE

For his final picture, Tobi wanted to make the most of the setting. To do this, he moved his shooting position until he was able to fill the background of the shot with the other snooker tables in the hall. He also decided to change the angle of the lighting. Instead of moving the main light to give frontal lighting he chose to leave it pointing down the table so that the picture was strongly sidelit. The table lights acted as a fill-in light source, bringing up shadow detail. Tobi posed Matt carefully and took the shot from a three quarter viewpoint to lend dynamism to the composition.

 ## Compact tip

❏ Many compacts set film speed automatically, using DX sensing to read the DX code on the side of the film canister. This is fine if you want to rate your film normally. But it can cause problems if you want to uprate a film to increase the graininess of your pictures. The best way around the problem is to buy sticky backed DX coded labels. These are printed with different bar codes for different film speeds. If you want to uprate a film all you have to do is peel off the backing paper and stick the required film speed label over the DX code on your film canister. The camera than reads the DX code on the label rather than the one printed on the side of the film canister.

 ## SLR tip

❏ The lighting in snooker halls can make exposure tricky. Large parts of the hall are dimly lit, which can fool your camera into overexposing your subject. Similarly, when you're photographing close to a table, and the table lights are included in the frame, your camera may underexpose the shot. For accurate exposures under these lighting conditions, move your camera close to your subject and take a reading from their face. If your camera has a spotmeter use this instead. Hand held incident lightmeters also give accurate exposures. But make sure when you hold the meter in front of your subject's face that it points *at your camera*.

People at work

Whether toiling in the fields, perched precariously up a ladder or hunched over the work bench, people going about their daily business present endless photographic potential. And even the most mundane task can produce a stunning image – if you take the right approach.

People are at work everywhere at all times of day and night, so finding subject matter is no problem. How you decide to approach your subject depends on the situation. Sometimes a candid picture is best – when you don't want to disturb your subject, for example. In other cases it's a good idea to get the co-operation of the person you wish to photograph, especially if you need time to set up the shot. For instance, you might want to surround a craft worker with the tools of the trade and examples of products. Vary your shots to include close-ups of workers' hands and faces, as well as long shots that place people in their contexts.

If you are entering a place of work, such as a workshop, factory or office, make sure you have permission to photograph from the person in charge – and remember to observe safety regulations at all times.

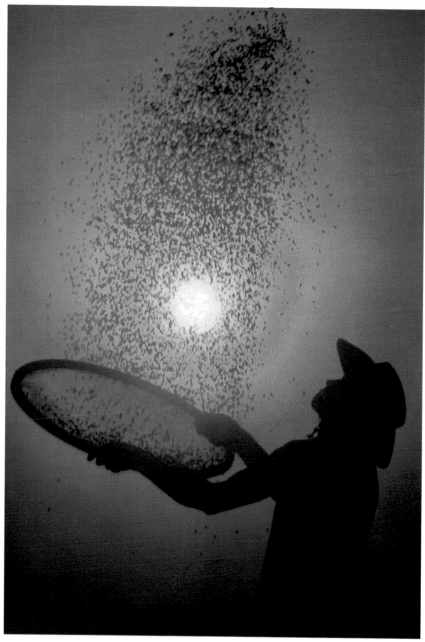

▲ GRAINY DAY
For this shot of a Colombian farm worker winnowing grain, the photographer threw his subject into dramatic silhouette by exposing for the sky adjacent to the sun. Cutting exposure time to make the silhouette enabled him to set a fast shutter speed, so the flying grains were frozen in mid air. To get a better chance of a special shot like this, it's worth seeking your subject's co-operation, however unlikely you think it is: people often agree.

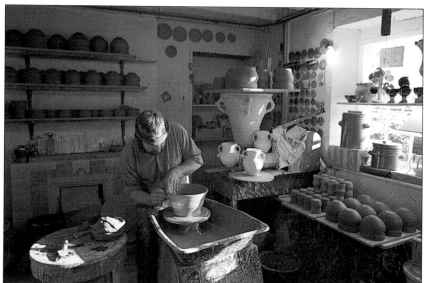

◀ UTTERLY POTTY
Whenever possible, make the most of natural light. Here, the warm hue of late afternoon sunlight enhances the image – flash would have broken the potter's concentration and spoiled the balmy atmosphere.

► LONELY FURROW

The attraction of this picture lies in the face of the farmer: though it is quite small, it nevertheless dominates the image, with his facial features picked out by low sidelighting. The beautiful colours of the landscape highlight the man's environment and set the scene. A small aperture setting increases the depth of field and ensures that everything in the picture is absolutely sharp.

▼ GLASSBLOWER

In certain situations it's worth taking time to set up a shot – with the agreement of your subject. In this shot of a glassblower the photographer has carefully arranged the picture to include the finished product – the fishes – with the glass kiln clearly visible behind. Several light sources were used to enhance the shot: one light behind the fishes illuminates them and the woman's face. A light behind her head brings out the steam and highlights her head, and fill-in flash reduces contrast in the figure and fills in the shadows.

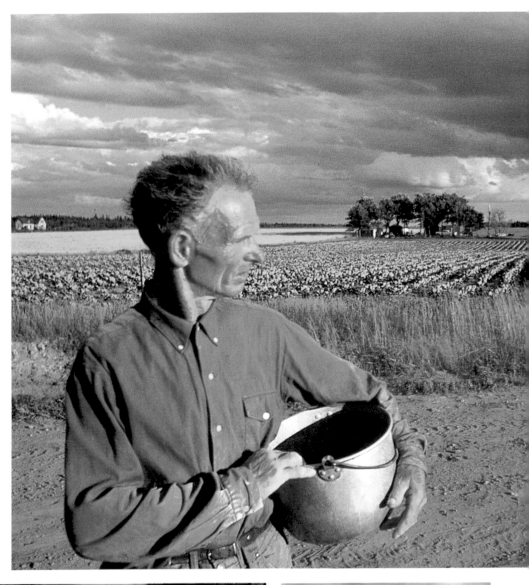

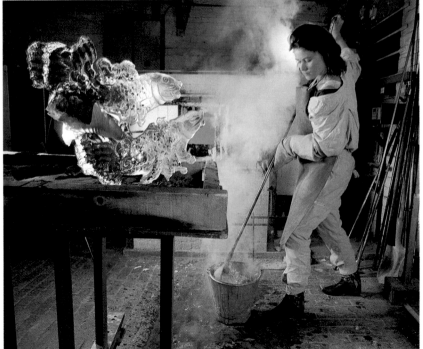

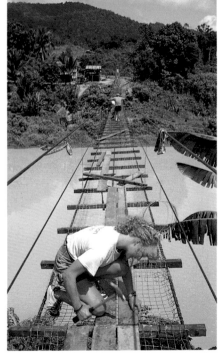

◀ IF I HAD A HAMMER
When the job in hand is unusual or set against an exotic backdrop, make sure you choose a viewpoint that exploits this to the full. Here the perspective from the end of the bridge puts the dizzy river crossing centre-stage.

▶ COLOUR CRAZE
Much of the appeal of this shot comes from the dramatic contrast of primary colours – a polarizer was used to darken the blue of the sky and make the contrast stronger. The photographer tilted the camera to create diagonal lines which make the image dynamic, and waited until the worker's face was clearly visible and not in shadow, before pressing the shutter release.

▶ WALL PAINT
In this picture intricate detail in one small part of the frame is juxtaposed with a wide area of flat tone. Such an expanse of plain colour could look dull, but in this instance it indicates the task in hand, so actually contributes to the image. The shot is very carefully composed to align the verticals and horizontals with the edges of the frame, creating a pattern of blue in subtly different shades.

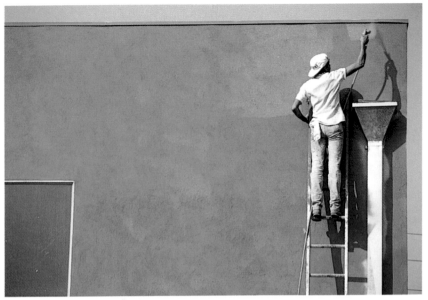

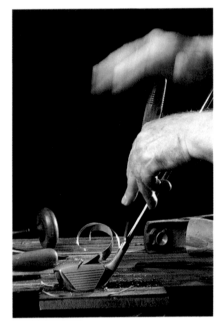

▲ CLUBBING
Fine skill merits precision on the part of the photographer. By closing in on the hands and including the tools of the trade, an expressive suggestion of craft work is represented. The photographer caught the craftsman's right hand just before it hit the chisel, so the hand is the only blurred element in an otherwise pin sharp picture – transforming it from a cliché into an ingenious action shot. A black background is created simply by keeping the light on the foreground.

▶ CLOSE SHAVE
Here the photographer was faced with the problem of shooting with his back to the window – the only light source – making a slow shutter speed essential. Waiting until the barber paused, before pressing the shutter release, ensured a crisp shot. Taken in Cyprus, the scene is set by fairly loose cropping to include the ever present portrait of Archbishop Makarios in the background.

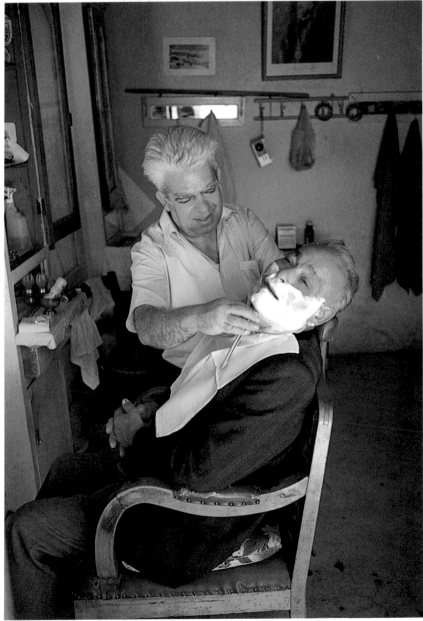

Candid outdoor group

Photographing people at work is fascinating, but people at play can be an equally rewarding subject, as David Jones finds out when he takes a Masterclass from Mike Busselle.

I've never been very good at taking party pictures. Either I fail to capture the magic moment or I forget about decent composition in the attempt. So when Mike Busselle asked me to accompany him on a candid outdoor shoot I jumped at

the chance, hoping that some of his experience and expertise would rub off.

Our brief was to drop in on a summer's afternoon gathering and try to come up with genuinely candid images of the guests. The conditions were a challenge.

The back garden in which our four subjects were relaxing was small, surrounded by dark green bushes and partly plunged into deep shadow by a group of tall trees next door. The sun was blazing down on to the rest of the lawn from almost directly above us. The subjects were sitting at a table in the right hand corner of the garden.

David's efforts

I decided to start shooting first, and immediately ran into problems. Using a Nikon FE2, Fuji 100 slide film and a tripod, I began photographing the foursome as they sat around a white table in the glaring sun. But I soon realized that the sun reflecting off the table would burn out all the detail around it,

▼ *David's first shots were taken with a tripod in blazing overhead sunlight. The subjects don't look very relaxed – in fact one of the girl's faces is completely obscured – but the main problem is harsh sunlight, which is bouncing off the white table and burning out everything on it.*

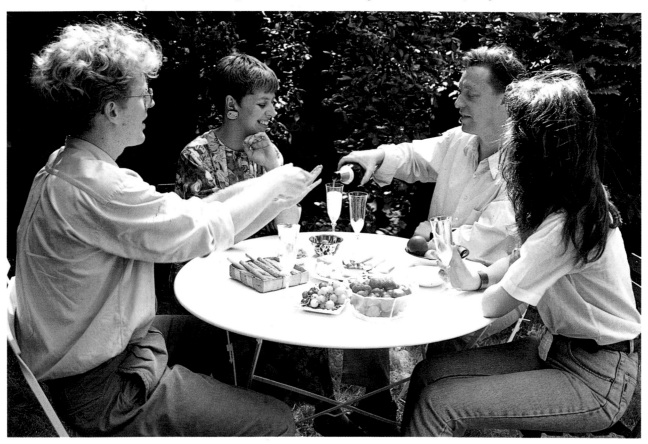

The set up

Mike and David were working in a small south-facing garden surrounded by dark green plants and shrubs that made the background tricky to work with. The sun was blocked out from the west by a line of tall trees running down

the right hand side of the garden, which left half the lawn in deep shadow, and the other half in brilliant sunlight. The table was in the bottom right hand corner of the garden, and Mike was shooting from sunlight towards the shade.

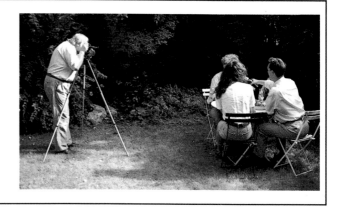

and Mike suggested covering it with a tablecloth.

I tried taking some shots standing up, but that didn't work because I was too far above the heads of the subjects and too far away from the table. So I moved in closer and tried a slightly lower angle. But then my composition went astray.

I found it very difficult to include all the faces in one shot, and I ended up including the back of someone's head instead. Because the subjects were all sitting at different distances from the camera, it was also very difficult to know which one to focus on. Given the added problems of too much top light and a dark background, it's hardly surprising that my shots were disappointing.

Mike moves around

When Mike took over, he moved right around the table in search of the best viewpoint before he started shooting. He realized that it would be impossible to include full views of all four faces in a candid photograph, so he settled for an angle showing two faces in full view and two in profile.

At first he tried using his tripod, but found it too restricting for this shoot and soon switched to hand holding. He chose a lower viewpoint than I had, just below the eye level of the sitters, that allowed him to frame a much more interesting

Tip

Try every angle

'Whether you're shooting candidly or not,' says Mike, 'remember to try every available angle. Don't just settle for the first viewpoint that occurs to you. Move around the subject as much as possible, try lower and higher angles and both formats. Only by experimenting will you find the best viewpoint.'

shot. Then he sat down and waited.

Within three quarters of an hour the lighting had changed significantly in Mike's favour. The sun

MIKE'S APPROACH

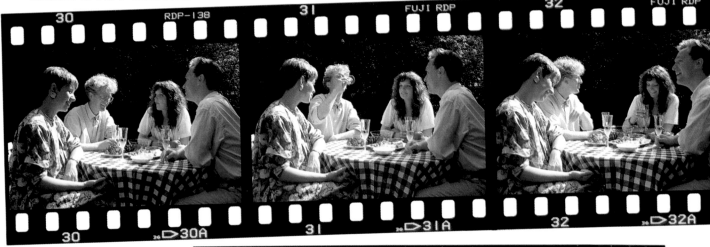

1 CHOOSING A VIEWPOINT
Mike explored every possibility before settling on a viewpoint that gave him a full view of two faces and profiles of the others. His composition is good but the subjects don't look that happy, and the background is far too dark. The glare off the white plates could be avoided with a lower camera angle.

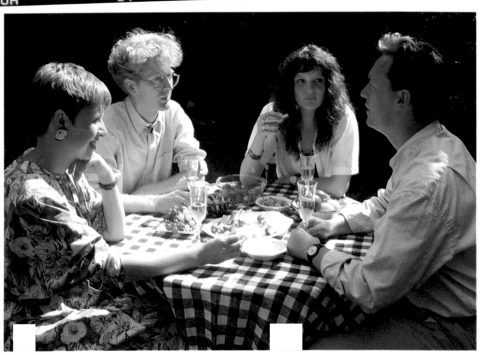

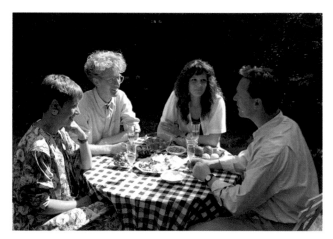

▲ A check tablecloth has solved one of David's difficulties, but the combination of glaring sunlight and deep shadow is still causing problems. The camera's too high, too far away and there's too much contrast.

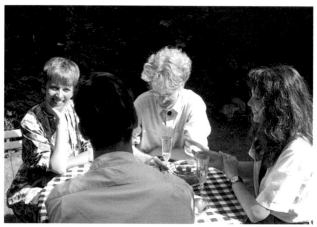

▲ David has changed his viewpoint, lowered his camera angle and moved in much closer for this shot, but his composition has let him down. An otherwise interesting photograph has been ruined by the inclusion of the back of a subject's head.

▲ Candid photography is a hit and miss business at the best of times. To stand any chance of producing good results, it's important to shoot a lot of film.

2 A LOWER ANGLE
Taking his camera off the tripod, Mike found a slightly lower angle that solved some of his lighting problems. There's a bit too much contrast and the background's still too dark, but there's no glare from the plates, everyone's more evenly lit and they look a lot more animated as well. But Mike knew he could do better.

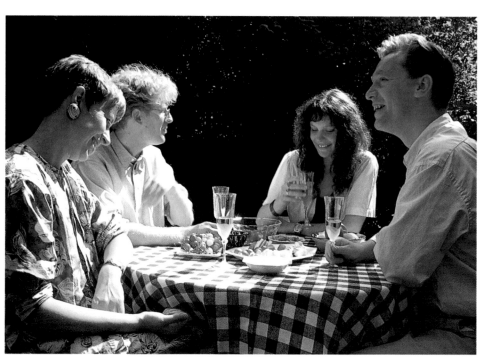

was a good deal lower now and a helpful haze had developed, which made the light much softer. With conditions as good as they were going to get, Mike started shooting, using the same film and camera as I had.

'I was looking for natural expressions,' he explains, 'and by now the long-suffering subjects were so used to me and my camera that they began to ignore me and get on with their conversation.

'Candid photography can be very difficult because there are no rules to help you. All you can do is make the best of lighting and location, wait for the subjects to forget you're there and be prepared to shoot at any time.

 SLR tip

❑ **Clip testing** When you have rolls of colour slide film taken in poor light processed, ask your darkroom to do a clip test before developing the film. A clip test involves cutting the first two or three frames off the roll and developing them normally. This will give you a good idea of how much the roll will have to be pushed (overdeveloped) or pulled (underdeveloped).

Changes in processing have a similar effect on every frame, so clip testing is useful only when every picture is taken with the same exposure in similar lighting.

 Compact tip

❑ **Exposure lock** Because they're so easy to use, compacts are perfect for catching candid moments. However, if you're photographing people with a zoom compact in poor light, the camera can be very easily fooled into making exposure error. You can avoid this with cameras that have an exposure lock by zooming in on one of the faces, taking the compact's exposure reading and locking it. Then pull back and take the photo using the same reading.

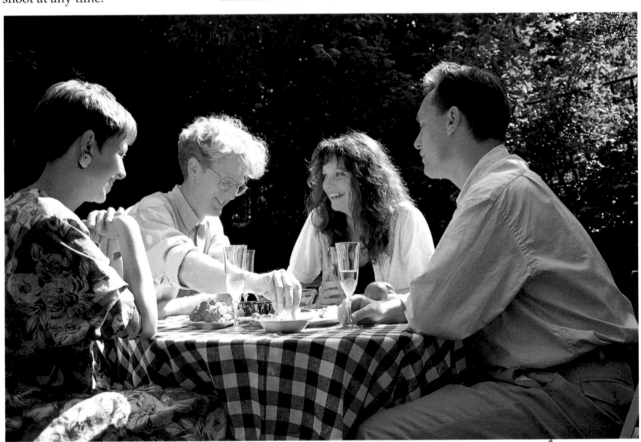

3 THE RIGHT MOMENT
By now the sun was lower in the sky and a helpful haze had developed, making the light softer and bringing up the background. More importantly, the sitters had become so used to Mike and his camera that they'd forgotten all about him. The result is a relaxed, well lit and genuinely candid photograph.

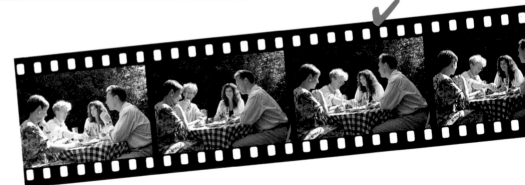

Taking a double portrait

Professional children's photographer Ray Moller shows Rhoda Nottridge how to take an informal double portrait using artificial light.

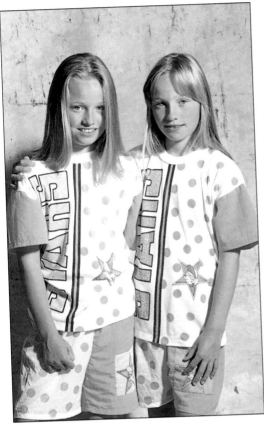

▲ *In Rhoda's first shot the twins look tense and unnatural. The pose is fairly formal, but they are dressed in casual clothes which suggest they should be running around. The shot has also been* *badly framed, with too much background at the top. Although the girls are wearing similar outfits, the clashing colours destroy any sense of uniformity.*

Tip **A blinking problem**

Kate kept blinking from a mixture of nerves and the strong lights in the studio. This spoiled some of the shots. 'It's important to notice if the model happens to be blinking a lot', says Ray. 'It often happens with children and it can ruin your whole shoot.

'The problem is easily solved – ask the model to close her eyes for a couple of minutes or rest her head with her hands cupped gently over her eyes. This relaxes the eye muscles and stops the blinking.'

Ten year old twins Kate and Vicki arrived at Ray's studio feeling very excited and a little bit nervous. It was their first professional assignment as models and they were really looking forward to it. For me, it was a chance to see how a professional copes with photographing two children in an indoor set up.

I decided to use Ray's Nikon F3 – its motor drive would come in handy if I wanted any action shots. I chose a 135mm lens, the maximum length of lens normally used for a portrait shot. This meant I had to stand some distance away from the twins. Ray's choice of film for both of us was Kodak Ektachrome ISO 100 for good colour strength.

Rhoda's shots

I used a single light source, a flash with a modelling light attached. The modelling light gave me an idea of the flash's angle in advance. The flashgun was on a stand, and a cable linked camera and light so the flash synchronized with the firing of the shutter.

The twins had arrived with an array of different outfits. I thought it would be fun to get them both to wear similar clothes. They had been telling us about their adventures at the seaside so I decided that bright, sunny shorts and T-shirts would suit them.

The set up

Ray and Rhoda were working in a studio. Both photographers used a studio flash with a modelling light attached to it. Ray used two reflector boards to throw light back into the shadowed side of the girls. He also put a sheet of tracing paper in front of the flash to help soften the light, which was too harsh.

A similar set up could easily be achieved at home. Use a heavy white sheet for the background, and an ordinary lamp stand fitted with a photoflood bulb for your light source if you don't have a detachable flash gun. (Remember to use a Kodak Wratten 80B blue filter with daylight film, or else tungsten film.) A piece of white polystyrene will work just as effectively as a shop bought reflector board.

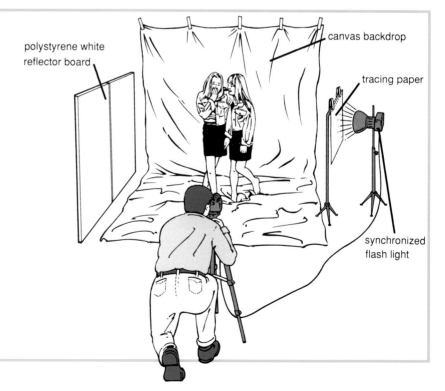

polystyrene white reflector board

canvas backdrop

tracing paper

synchronized flash light

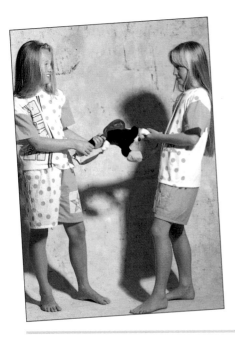

I used one of Ray's neutral, mid-grey backdrops to avoid any confusing background details. So far, I thought, so good. That was when it started getting tough. I found it difficult to pose the two girls in a way that expressed their energy and enthusiasm. I also wanted to make something out of the fact that they were twins but I wasn't sure how to go about it.

◀ *To bring some action into the shot, Rhoda got the girls to tug on a prop in a mock fight. Although a good idea, this created two problems. The twins are the best of friends so getting them to pretend to fight didn't work. It's usually better to suit a shot to the models' personalities. Also, moving them away from the backdrop with the flash on one side cast ugly shadows.*

Creating a look

When Ray took over, he laid all of Kate and Vicki's clothes out on the floor and spent what seemed like hours choosing the outfits. Watching him working out what the twins should wear made me realize how important clothing can be in creating a good portrait. Ray explained that he wanted matching outfits so that the only contrast would be the most interesting one – Kate and Vicki's faces.

The girls didn't have any matching shoes that Ray liked, so he went for bare feet. For a more casual look, he got the girls to roll up their sleeves. This attention to detail was one of the differences between my shots and Ray's.

THE PROFESSIONAL APPROACH

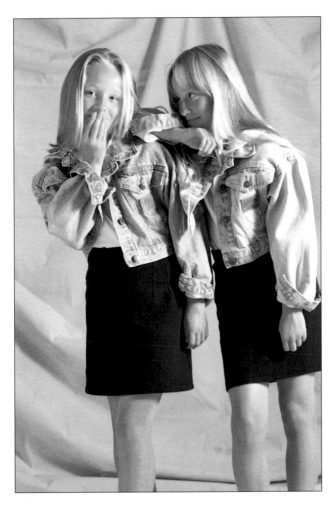

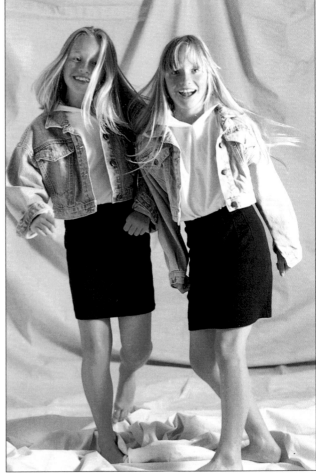

1 CHANGING THE BACKGROUND
Ray has removed the uninteresting grey backdrop and replaced it with a piece of beige material that gives the background much more texture. He also asked the twins to change into identical outfits, to emphasize their similarities.

2 USING MOVEMENT
To get the girls moving around, Ray asked them to turn their backs to the camera and spin around in opposite directions, so they ended up facing the camera. This gave the shot spontaneous movement, but the light is still harsh.

Ray used a piece of beige material instead of my flat grey background. He pinned it across the back of the studio and trailed it over the floor. He then pulled it around to make lots of folds – 'you can use material to create a bit of texture in the background', he explained.

Child psychology

I began to realize that there's a lot of psychology involved in photographing children. First of all, Ray got the girls to lean against each other. Each time they reached a certain angle, one of the twins would start to fall over and they would both erupt into a fit of giggles.

This made the girls feel more relaxed. Ray soon noticed that Vicki (on the right in the photos) was the more boisterous of the two sisters, so he tended to get her to do most of the moving around, which came to her quite naturally.

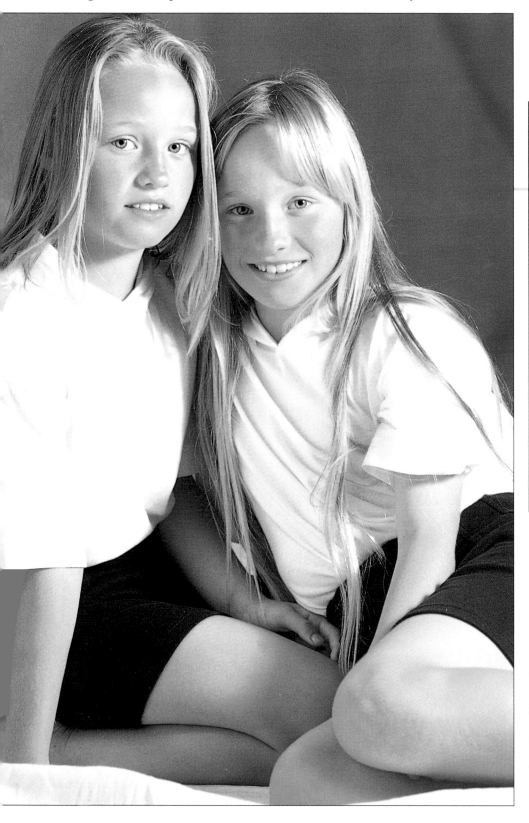

Tip Using Polaroid

'If I'm involved in an important shoot', says Ray, 'I often take Polaroids first. This shows up any faults I might have overlooked such as messy backgrounds. When you've been arranging a shot for some time, the eye sometimes fails to spot a problem which becomes glaringly obvious if you look at a Polaroid photo.

'I also find it useful when photographing children – if I can show them straight away what it is I'm doing, that helps keep them interested in being photographed.'

3 CLOSING THE GAP
For a more formal shot, Ray got rid of the denim jackets and asked the twins to lean together naturally. He moved the light's angle forward to darken the backdrop and make the twins stand out, and used a sheet of trace to soften the harsh light.

Getting more movement

Once Ray had established a good atmosphere, he got the girls to jump around, starting with their backs to the camera and then spinning round as fast as they could to face it. Ray rehearsed this several times before he began to take pictures. By the time he had started snapping, Kate and Vicki were really having fun.

4 MOVING IN
Ray then asked the twins to lie down and moved in close to take this effective study. He'd lowered the light source accordingly, and for both this shot and the one before he altered his exposure to deal with the extra light being cast up by the white shirts.

 Compact tip

❏ If your compact has an anti red eye facility, you'll get more spontaneous indoor portraits by turning it off. The flashing light that precedes the shutter opening alerts your subjects that you've pressed the shutter release, and gives them time to pose for the camera. With the device switched off, the shutter opens the instant you press the release – not after a moment's delay.

Prevent red eye by placing a light behind the camera. The light will have little effect on film, but your subjects' pupils will contract.

 SLR tip

❏ If you'd like to try shooting a similar shot to this one but don't have any twin models handy, don't despair. Using multiple exposure, you can double the fun of a conventional portrait.

Mask the left half of the front of your lens and photograph your subject on the right side of the picture. Then move mask and subject to the opposite sides, re-tension the shutter without advancing the film, and make the second exposure. You'll need a tripod to keep everything correctly lined up in both exposures.

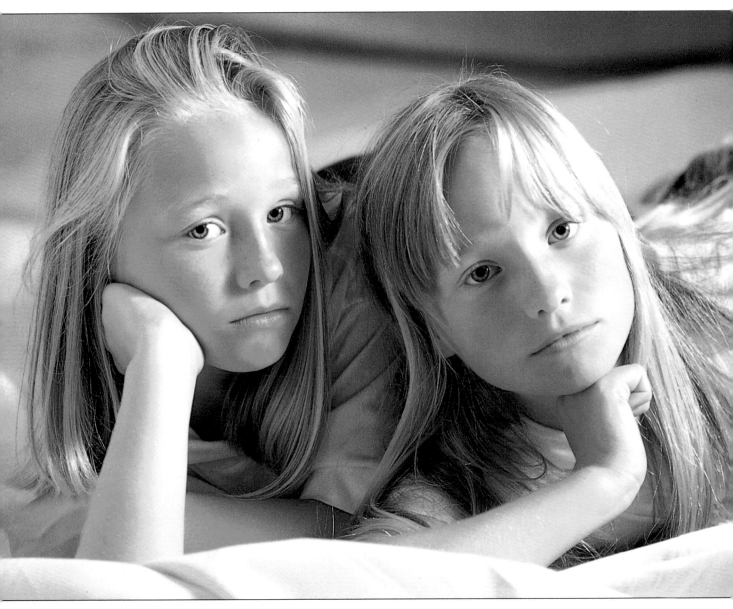

Taking the family's portrait

Professional portrait photographer Vincent Oliver shows Rhoda Nottridge how to produce a relaxed picture of a family group at home.

Have you ever tried forcing your family to shut up and stay still while you snap away for the sake of the family album? My efforts have always ended in failure, so I asked Vincent Oliver to reveal the secrets involved in taking a decent family portrait. Our models for the day were the long-suffering Neale family, who kindly let us photograph them at home.

We decided to look for a fairly formal group portrait. We both used Nikon FE2s, and I left the choice of film to our professional. Vincent chose Ektachrome 100 Plus colour transparency film, which gives good skin tones and just an extra hint of yellow to help warm up the shots.

▼ *The Neale family look fairly relaxed in Vincent's first shot, but their heads are too far apart to make the group look intimate and the background is far from perfect.*

The set up

Vincent and Rhoda were shooting in the Neale family home. They worked in a long through-room that includes a lounge and dining room.

They both started by using the sofa in the front area of the room, but Vincent soon moved on to the dining area to avoid background clutter and to find a few props that might tell the viewer something about the family. The rooms had high, white ceilings with a slight pink tinge to them.

Both photographers initially used hotshoe flash, but Vincent then decided to use a more powerful flash unit which plugged into the mains instead.

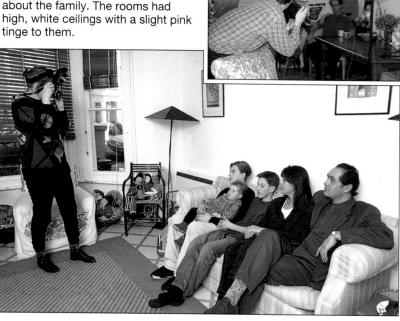

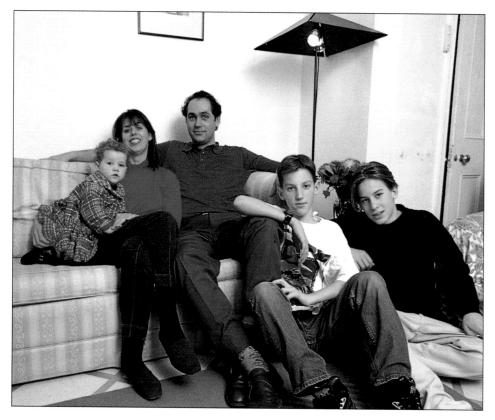

Tip

Catching the moment

'Working with a group that includes a small child can be difficult', says Vincent, 'and you often have to work very fast before the little one loses interest.

'One problem can be that everyone looks towards the child to get it to look at the camera and they stop looking at the camera themselves. So first make sure all the rest of the group are looking the right way. Instead of waiting for the child to react, just start snapping and eventually the child will look the right way.'

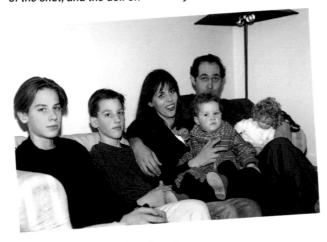

▼ In Rhoda's first shot there are some easily avoidable errors. The arm of the sofa juts into Alex on the left side of the shot, and the doll on the right side is very distracting – it almost looks like another baby! The lamp is also distracting, and the boys look bored.

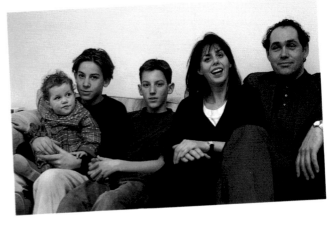

▲ Here, there's a problem with the lighting. To soften the shadows, Rhoda pointed the bounce flash head up to the ceiling. But the ceiling's pink tinge coloured the light. Also, the ceiling was too high for the flash to reach effectively, leaving the picture looking too dark.

POSING THE GROUP

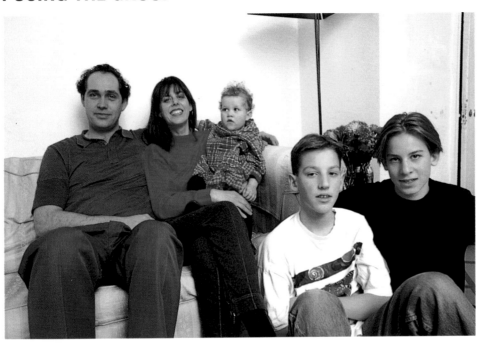

1 A STILTED BEGINNING
Vincent started by trying out a variety of seating compositions and experimenting with the lighting. He turned on the tungsten lamp behind the family to see what kind of light it would cast. Then he asked the mother to change into a brighter top and added flowers to liven up the shot. But the picture looks clumsy, with the boys badly placed in front of the flowers and lamp stand.

Lighting problems

I started shooting first, with a 50mm lens and a flashgun mounted on the camera which I aimed straight at the family. But direct flash casts very hard shadows behind the subject, so I decided to try bouncing it off the ceiling. This scatters the light over a wider area and softens the shadows.

Using a standard 50mm lens in a small living room was a mistake. I ended up walking backwards into a chair because I didn't have enough space to fit the whole family into the shot – a wider lens would have helped. My other big problem was the ceiling, which was too high for the flash to bounce off effectively, so most of my shots came up far too dark.

Vincent takes over

Vincent started off by looking at the shape the family group made sitting on the sofa. He played around with different seating arrangements, looking for the best position. 'One of the commonest mistakes', says Vincent, 'is to string a group out along a sofa. All that gives you is a long, thin, uninteresting pic-ture. Try to create a rounder composition, so that the eye moves from one person to the next in a circular way.'

A wider angle

By using a 24mm wide angle lens, Vincent made sure he had a lot more room for manoeuvre. But it also meant a lot more would end up in the shot, so he tidied away any toys, magazines and other bits and pieces that would have cluttered up a wider shot.

To begin with he used a small flashgun attached to the camera to

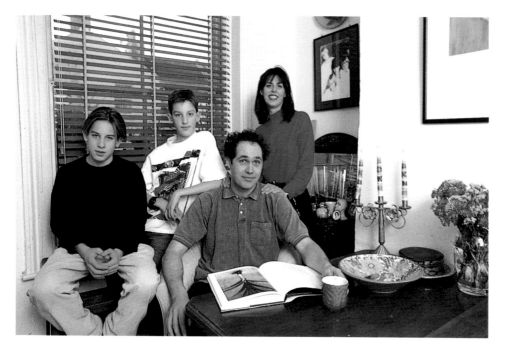

2 CHANGING TACK
By moving the family into the dining room and using a 24mm wide angle lens, Vincent managed to include some of the objects which are part of the family home and reflect more of the group's personality. With the mother and one of the sons standing, the composition takes on an interesting new shape and the lighting's perfect. But the shot looks a little too cluttered.

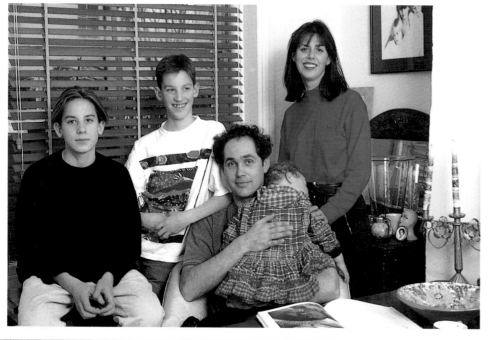

3 SLEEPING BEAUTY
All the excitement of a family photograph had proved too much for baby Alice, who fell into a deep sleep. The family decided they wanted to keep her in the picture anyway, and the tiny sleeping figure adds a touch of tenderness to the shot. But the mother looks isolated and uncomfortable on the edge of the group and the busy background has become a little too distracting.

bounce light off the ceiling as I had, but he opened up the aperture to compensate for the extra distance the light had to travel.

In the end, though, the colour cast from the slight pink tinge on the ceiling worried Vincent and he decided to use a mains power pack flash on a stand instead. He diffused the light by bouncing it off a white umbrella behind the stand.

Talking to the family
Vincent was not happy with the set up so far. The family weren't sitting comfortably and looked awkward, so a change of location was needed. Baby Alice had by now lost her fleeting fascination with the 'magic' flash and was getting grumpy. We decided to stop for a tea break.

Vincent chatted away, asking the family about their work, school and special interests. 'I like to find out as much as I can about the people I'm photographing and activities that they do together', Vincent explained. 'If they have a particular interest in common I try to incorporate it into the shot.'

Vincent had discovered that the Neale family were very artistic. They had lots of colourful objects in the room, and he felt the family would look more at home surrounded by some of their belongings.

Perhaps partly because the Neales felt on more familiar territory, they had finally begun to relax. Vincent also pointed out that it takes time for people to feel at ease. 'I never expect to get any decent shots from the first roll of film. It takes that number of pictures before most people start to feel comfortable.'

Closing in

The Neales were now much more comfortable – in fact little Alice had become so relaxed that she'd fallen asleep! Vincent felt the time had come to concentrate on the family's faces.

He changed the wide angle to an 85mm lens – the ideal lens for portraits. Vincent was careful to leave a little bit of space round the picture.

'You don't want to leave too wide a margin, but a little can be useful. If you're not happy with the way you've framed the shot afterwards, you can always crop the prints. It's also a good idea to take your shots in groups of two. A lot of people tend to tense up before a picture's taken, so the sound of the first shutter release often relaxes them and makes the second photograph much better.'

 Compact tip **SLR tip**

❏ The larger the group you're photographing, the harder it is to get a picture where everyone's smiling and open-eyed. The only way to be sure of a good group portrait is to shoot a lot of film.
❏ The camera tends to make people look further apart than they actually are. If you want to take an intimate group portrait it's important to make sure everyone's sitting very close together.

❏ To combat any loss of light you might get when you're bouncing flash off a high ceiling, take the unit out of the camera's hotshoe and move it closer to the ceiling. (Tape the gun to the top of a door or shelf). You can synchronize the flash with a slave cell, triggered by firing a tiny flash from the camera's hotshoe. The light from the flash on the camera will also put a twinkle in everyone's eye.

4 A CLOSE FAMILY
Going for a close-up shot, Vincent asked the Neale family to move in nearer to each other so there was very little space between their heads.

By using an 85mm portrait lens, he could get right in for a close shot without having to tread on the family's toes. All the family look relaxed and happy here.

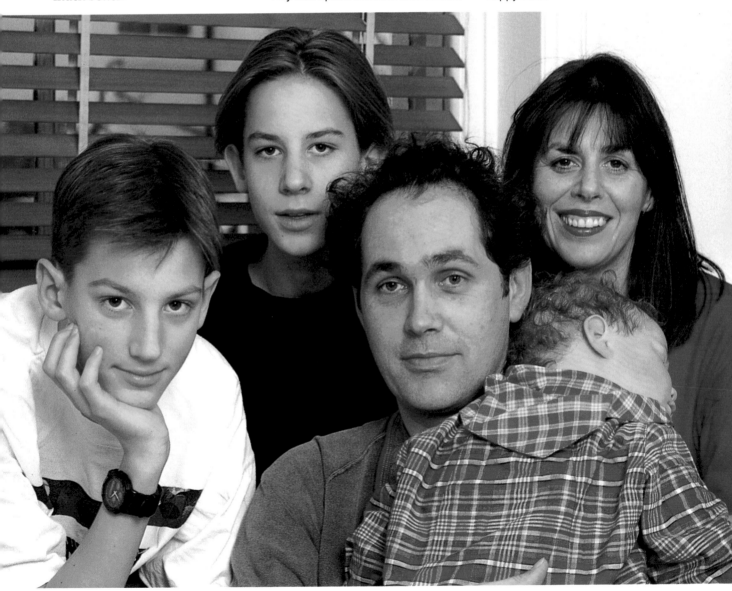

Putting yourself in the picture

As a photographer you'll often find yourself taking pictures of other people. But every now and again it makes a change to star in your own photographs. Most cameras let you do just that – using a self-timer or a cable release.

▲ ▶*Compact cameras and SLRs with electronically controlled shutters use electronic self-timers. SLRs with mechanical shutters use a simpler clockwork self-timer mechanism.*

Imagine you're on holiday with family or friends and everybody's posed for a group photograph. Being a keen photographer you are the obvious person to take the picture, but that means you won't appear in the shot. Or what about if you're travelling alone and want a picture of yourself as a memento of the trip – would you trust a complete stranger to take the picture using your valuable camera and equipment?

Fortunately, most cameras have a self-timer (also known as a delayed action timer). This delays the firing of the shutter for a given period – so the photographer has a chance to race in front of the camera and appear in the shot.

Self-timers have other uses apart from holiday snaps and self-portraits. For example, you can include yourself in a landscape shot to add foreground interest.

Beat the shakes

It's easy to cause camera shake when you're using long exposures – even when the camera's on a tripod. Pressing the shutter release alone can be enough to cause vibrations. The problem is worse with long lenses, which exaggerate any shaking. Using the self-timer helps cure the problem – you're not touching the camera at the time of the exposure and all vibrations have ceased by the time the shutter fires.

Self-timers are also useful if you're photographing a reflective

subject like a glass fronted building. The reflection of the camera is usually not too obtrusive, but the photographer's reflection can ruin the shot. Activating the self-timer gives the photographer time to get out of the shot before the shutter fires.

Direct link

If you use an SLR, an alternative to a self-timer is a cable release. This screws into the shutter release button, or into a separate socket on the camera body, and lets you fire the shutter from a position away from the camera. The advantage of a

cable release is that it gives you more control over when the shutter fires.

It's easier to take self-portraits as the shutter can be fired when you're in position. But you need to be careful to conceal the cable release so that it doesn't show in the picture.

A cable release can also be useful if you are photographing under changeable lighting conditions. With a self-timer, the light can change between the time you activate the timer and the shutter firing. With a cable release the shutter fires immediately.

▶ *A self-timer is useful if you want to take holiday pictures of the whole family. Alternatively, you could use a cable release, but try to conceal the cable so that it doesn't appear in the shot.*

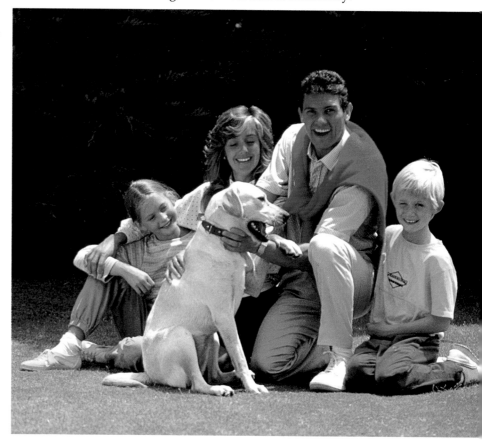

Self-timers

Some cameras use a simple, mechanical self-timer on the front of the camera. You just rotate a lever through 90° or 120° – depending on the camera – and then press the shutter release. A clockwork mechanism rotates the lever back to its original position. When the lever reaches this point, the shutter fires. The lever usually takes about 10 seconds on its return journey. Some cameras have variable settings to let you alter the length of the delay before the shutter fires.

Modern cameras with electronically controlled shutters use electronic timers. Many of them let you program the length of the delay. You can usually set between two seconds and 30 seconds, in one second intervals.

Some cameras offer a dual frame option. The camera takes two shots – one after ten seconds and another five seconds later. Others have a multi-frame option, which lets you choose how many shots are taken – from one to five.

Zoom into action

Certain zoom compacts have an advanced self-timer function that takes two shots – the first at the chosen zoom setting and the other at the lens' widest setting. This gives you a choice of compositions. A few models let you set up to ten zoom settings for greater variety.

▲ *The first shot is taken after a delay of 10 seconds at the zoom setting chosen by the photographer – 85mm in this case.*
◀ *Five seconds later, the lens automatically zooms to its widest setting and the camera takes the second shot.*

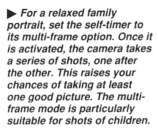

▶ *For a relaxed family portrait, set the self-timer to its multi-frame option. Once it is activated, the camera takes a series of shots, one after the other. This raises your chances of taking at least one good picture. The multi-frame mode is particularly suitable for shots of children.*

◀ *Air (bulb) releases stretch for several metres and are useful if you're standing far from your camera.*

Cable releases

There are several types of cable release to choose from and most are available in a variety of lengths.

Mechanical cable releases screw into a socket on either the shutter release button, the camera body or the lens. Pressing a plunger pushes a thin metal rod down on to the shutter button, firing the shutter.

If you need to hold the shutter open for a long exposure, then you can use a screw lock or twist and lock mechanism keeps the plunger depressed.

Mechanical releases are relatively cheap and there are many different lengths of cable to choose from. Hard wearing teflon coated versions tend to cost a bit more.

Electronic cable releases appear on modern cameras with electronically controlled shutters. These are attached to the camera via electrical contacts in a socket on the camera body.

Electronic releases are more reliable than mechanical types, but they are more expensive. There is

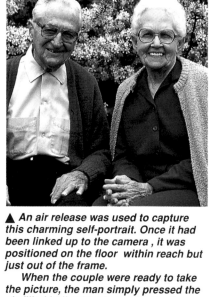

▲ An air release was used to capture this charming self-portrait. Once it had been linked up to the camera , it was positioned on the floor within reach but just out of the frame.

When the couple were ready to take the picture, the man simply pressed the air-filled bulb with his foot to fire the shutter. This allowed the couple to relax since there was no need for them to hold fixed facial expressions for several seconds.

also less choice when it comes to different lengths. However, on some cameras you can fit an adapter so you can use mechanical releases instead.

Air (bulb) releases are useful if you want to stand a long way from the camera during an exposure. These are available in lengths up to 20 metres and come on a plastic reel to prevent the cable getting tangled.

To operate an air release you squeeze a bulb at one end. This forces air down the hollow cable, which is attached to the camera in the same way as a mechanical release.

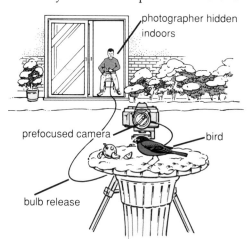

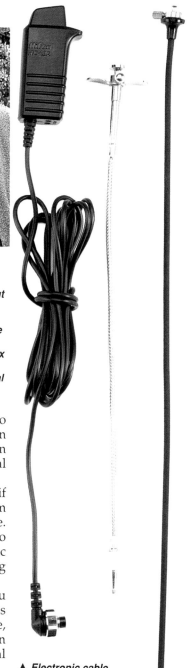

▲ ▶ If you try to photograph near to a bird table, you're likely to scare all the birds away. An alternative approach is to set up your camera on a tripod in the garden, and fire the shutter from indoors using an air release.

▲ Electronic cable releases are designed for use on modern cameras which have electronically controlled shutters. They are reliable and hard wearing.

▶ Mechanical cable releases are available in a wide range of different lengths and designs. They can be attached to the electrical socket found on modern cameras, using an adapter.

In the frame

It takes some practice to get self-portraits right, mainly because it's difficult to compose a picture if you're not looking through the viewfinder when you take the shot.

You can try leaving plenty of room at the edges of the frame. This reduces the risk of 'cutting your head off', but the pictures lose a lot of impact.

A better alternative is to use a position guide. This can be a mark on the floor so that you know where to stand. Otherwise you can include an object – a tree, for example – in the picture. If you then lean against the tree you can judge where you'll be in the shot.

If you're shooting indoors you can use makeshift frames to aid composition. For example, you can move the camera so that the edges of the viewfinder image lie just inside a doorway at about head height. Mark the top and bottom of the image area in pencil or sticky tape on the doorposts. Then all you have to do is position yourself in the doorway at the right height. Hanging a sheet or piece of board behind the door gets rid of distracting backgrounds. For tightly cropped head shots use an empty picture frame instead.

▲ *Doorways make useful composition aids for indoor self-portraits – maybe of you as a budding photographer! Use a pencil or sticky tape to mark the image area on to the doorframe. This way you can tell at a glance where to stand. If you're too tall for the doorway, sit on a stool.*

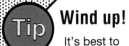

Take your time

Long exposures can produce dramatic photographs that the eye would otherwise not be able to see. For example, at a slow shutter speed of several seconds, flowing water takes on an attractive mist-like appearance and car lights are recorded as trails of light.

Most SLRs and many compacts let you set slow shutter speeds – up to several seconds. But if you want to use an exposure longer than the camera's slowest shutter speed you need to use an open shutter setting.

The B (bulb) setting lets you hold the shutter open for as long as you like – it won't close until you take your finger off the shutter button. Most cable releases have a locking mechanism that keeps the shutter release depressed without you having to hold it manually. This reduces the risk of camera shake when you're using long exposures.

Another function found on a few

cameras is a T (long time exposure) setting. The difference between this setting and the B setting is that the shutter doesn't close when you take your finger off the shutter button. To

close the shutter you have to press the button again or turn the shutter speed dial to another setting.

BACK TO BASICS

▲ *Some cameras have B and T settings on a shutter speed dial. Selecting a setting is simply a case of turning the dial to the appropriate letter.*

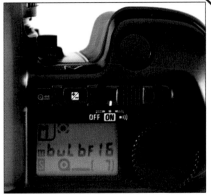

▲ *On others you set B and T on an LCD display, using an information input wheel, sliding switch or control buttons.*

Birthdays

A child's birthday party is a great time to take out your compact and capture some candid pictures.

1 Planning

Even for shots that look unposed, a little preparation is helpful, especially if you want to concentrate your picture taking on one particular child.

Before the party begins, think about the best place to position yourself when the child opens their main present, for example, or waves goodbye to their guests at the end of the day.

If you're organizing the party yourself, you can draw up the seating plan so that your subject sits just where you want them to. If someone else is in charge, why not have a word with them before the party starts?

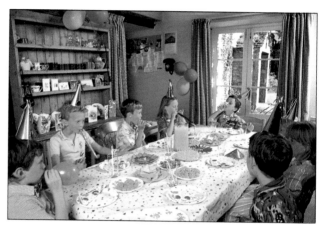

▲ *Move round the table as you take your photographs so that you can capture every child's face in at least one picture.*

2 Composition

This partly depends on what lens your compact has. A short focal length like 35mm is ideal for including several children in the picture without you having to step so far back that you knock into the wall or move out of flash range.

On the other hand, the longer focal lengths found on many zoom compacts, like 70mm, allow you to concentrate on just one or two children.

You'll probably have no choice but to include backs of heads in some of the shots, so take lots of pictures from different angles. That way you should see every child's face in at least one shot. If the table is long, shoot from both ends of it.

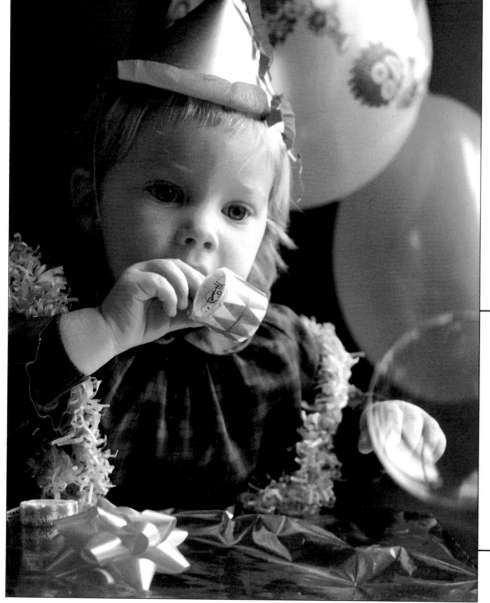

composition 2 mood 4

planning 1 props 3

◀ *Window light provides enough illumination here. In a dimmer room, use a burst of fill-in flash.*

3 Props

Presents are ideal props – they add interest and provoke lovely expressions on children's faces. If a child has been given a very large soft toy, for example, take advantage of the picture opportunity.

If you give your subject something to play with, do make sure that he or she is the rightful owner! Otherwise you may be faced with tantrums or worse by the true owner of the prized possession.

composition **2**

mood **4**

props **3**

planning **1**

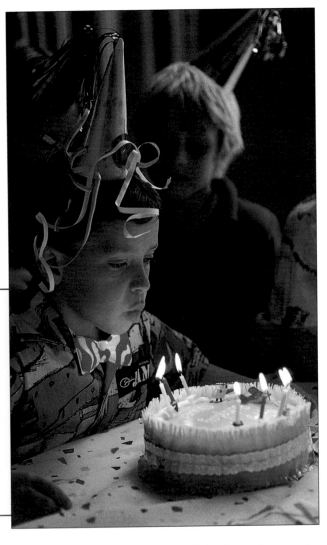

◀ *Here, the photographer used available light only so that the glow of the candles throws a lovely warm light on to the boy's face.*

CHECK IT! ✔

Camera: compact with built-in flash.
Film: ISO 200 or 400 print film, depending on the light level; ISO 1000 if you want to switch off the flash and record candlelight.
Camera support: not recommended.
Filters: not necessary.
When to shoot: photograph when the party is in full swing, so that the children have lost their shyness. Teatime is an excellent source of pictures.
Props: any presents.
Safety note: if you're shooting near food, watch out for children throwing or spilling it. Don't leave your camera unattended and cover the lens when you're not shooting, to avoid mishaps.

4 Mood

Candlelight is excellent for atmospheric photographs, and a birthday party is a natural place to find it. But it's tricky to capture the glow of candles on film if you have a compact. Using flash destroys the atmosphere and makes the candles insignificant.

With advanced compacts, you can switch off the flash and still record an acceptable image because the camera automatically increases the exposure length. However, if you're not using a tripod there's a high risk of camera shake.

There are a couple of ways to get round the problem. Try leaving the door to an adjacent (brightly lit) room ajar, or close in as the child blows out the candles so you fill the frame with light.

Alternatively, if you have an advanced compact you could load up with ultra fast film like ISO 1000. This will result in an attractive grainy effect especially suitable for low light pictures.

But do check first in your camera's manual that it is capable of reading this speed.

◀ *If you're aiming to shoot races outside in the garden, step as far back as possible. That way you have time to take more than one shot before the children bear down on you.*

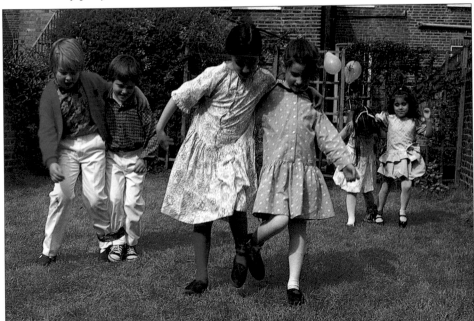

Weddings

Weddings are a perennially popular subject. You can get excellent pictures with compact cameras, though you might get even better results with an SLR.

1 Viewpoint

Move quickly, because everyone else will have cameras or camcorders too, and will be looking for a good angle. Try to nip out of the church as soon as the last bridesmaid has gone past so you don't get caught among chatting groups at the church entrance.

Walk away from the main group of photographers so you don't end up with the same shots as everyone else. Once the official photographer has arranged a group of relatives, it's a good ploy to turn around and photograph those people watching from the sidelines – catching them unawares will give you natural spontaneity, as they don't expect to be your subject.

Make sure you don't get in the professional's way, though – he or she won't thank you for it.

▼ *Using the longer end of a compact's zoom lets the photographer capture wellwishers grouped around the couple, with no distortion.*

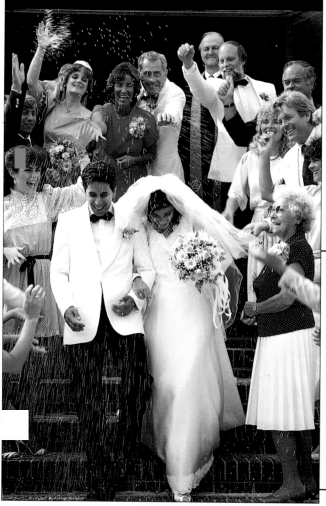

2 Composition

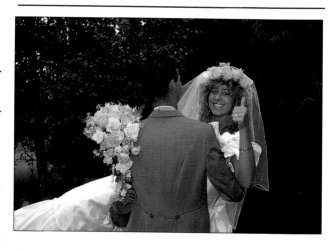

▲ *Quick reflexes and an autofocus camera allowed the photographer to capture this out of the ordinary pose.*

A lens of around 35mm lets you include other relatives and friends around the couple. If your camera has a zoom lens of, say, 35-80mm, you can switch to its longest focal length and record facial expressions while keeping your distance. It also blurs the background so it doesn't compete with the subject(s).

There will be plenty of formal portrait shots taken by the professional, so why not catch the couple as they circulate round the guests, talking and laughing?

3 Props

Traditional items like the bride's bouquet, glasses for the toast and the cake aren't exactly props, but they have a lot of picture potential.

You need quick reflexes to catch exactly the right moment when the rice or confetti is still aloft, for example, or when the bride throws the bouquet into the air. Keep your camera switched on and leave the lens cap off for these moments (but don't leave the flash on because of the drain on power).

Be ready to shoot when the couple are about to leave – record their expressions when they see the decorated car!

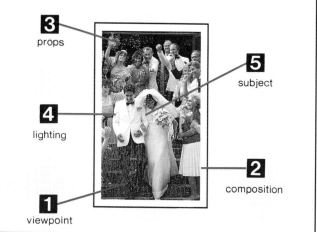

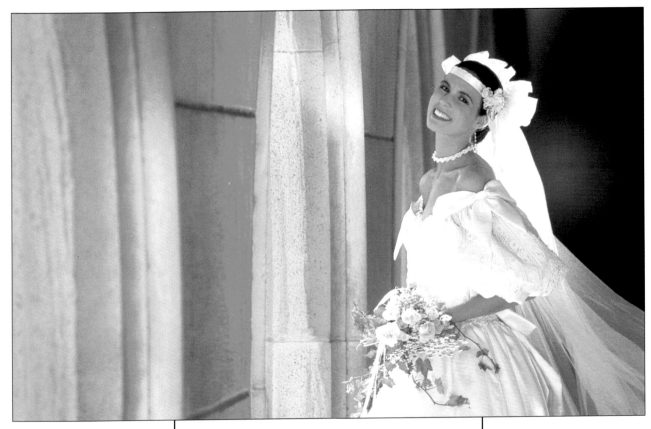

▲ *Calling out the bride's name will make her turn towards you – press the shutter at once, before she looks away again.*

4 Lighting

On a sunny day, you'll often find the sun streaming in through the church windows or arches. Capturing your subject bathed in light can make an excellent picture. With a compact, you'll need fill-in flash because of the low light level.

Fill-in flash is also handy if the sky suddenly turns black and thundery. Remember that your flash won't cover a whole group, so move within a couple of metres of the person you want to photograph and use fill-in flash.

At the reception, watch out for red eye in your shots, because people are likely to be drinking alcohol, which dilates their pupils. Try to shoot when people are not looking directly at the camera.

5 The subject

Don't assume that you should train your camera only on the bride and groom! Other people make great subjects as well. For example, you could capture the bridesmaids and page-boys playing, or the father of the bride relaxing after the ceremony. It's a great opportunity to record on film people who haven't seen each other for a while.

With a bit of luck, the wedding guests will be chatting and enjoying themselves, giving you lots of opportunities for snapping them unawares.

▲ *Try to capture the bridesmaids in a delightfully unselfconscious pose, like this one.*

CHECK IT! ✔

Camera: a compact with flash and a zoom lens, that fits into your pocket or handbag, is ideal.

Film: outside, ISO 100-200 if it's sunny; ISO 400 if it's not. Indoors, ISO 200. Print film tolerates slight exposure errors, and reprints to send to relatives are cheap.

Camera support: not necessary.

Spare batteries: recommended.

Props: confetti, rice, bouquet.

Weather: take an umbrella if it rains and ask someone to hold it over you and the camera while you're shooting.

Note: ask the vicar's permission beforehand if you want to take photos inside the church.

Large groups

Although group shots can be a part of photgraphing weddings, they also involve specific techniques of their own, as described here.

1 Format

It's not surprising that most group shots are landscape – this format makes it relatively easy to arrange your subjects. However, don't overlook the vertical option.

The secret is to position people at markedly different heights. If there are no steps nearby, make use of chairs or packing cases, or ask the ones in front to kneel down.

Lenswise, use a wide angle. For a really long line, panoramic cameras are ideal. However, especially with lenses shorter than 28mm, the people at the right and left edges may appear distorted. Try to avoid figures stretching right to the frame edge.

▲ *It's obvious what unites this group. The photographer lit the shot by two flash lights.*

2 Viewpoint

The size of the group will influence your position for taking the picture. A step ladder comes in handy for an impressive overhead view which lets you see everyone's face. Alternatively you could shoot out of the window from a building's upper floor.

A more unusual result can be achieved by crouching down and pointing the camera upwards; but the figures nearest the lens may well be distorted.

If you're photographing a single line of people, you'll be able to include everyone's faces easily, so you can just shoot at your subjects' eye level.

1 format
4 props
2 viewpoint
5 location
3 organisation

3 Organization

For posed shots, allow enough time for arranging everyone, but don't spend too long or your subjects' boredom could show in their faces.

If you're photographing a large number of people you need to make yourself heard. Give clear instructions as to where everyone should stand and make sure these are followed. With very large groups, an assistant is useful.

A whistle comes in handy for attracting people's attention – blow it then press the shutter at once, while all faces are turned towards you.

For more relaxed, natural looking shots, there's another trick you can make use of.

Count backwards from three to one, but on the count of 'one', don't press the shutter release. Instead, wait a couple of seconds, then take the picture.

With a motordrive, you can take two pictures in quick succession for the same effect.

◄ *Tell a joke to your subjects, then photograph the reaction for a lovely informal portrait.*

1 format 5 location

4 props 2 viewpoint

1 Props

Unless your subjects are in uniform, it can be difficult for the viewer to work out exactly what they have in common. Solve the problem by including in the picture objects they use in their work or hobby.

Musicians could hold the instrument they play – or show them in action. One large object can be used to bind the group together – think of several mechanics standing round a car.

With a smallish group, you could ask your subjects to sit on a long bench so that all their faces are on the same level.

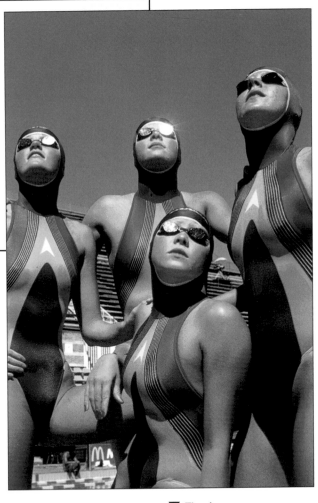

▲ For humour emphasize the unusual as the low camera angle does in this group portrait. Crouching down also cuts out some of the background clutter.

▼ The drummers were arranged into a circle and photographed in action from overhead. A wide angle lens exaggerates the curved pattern.

5 Location

Choose to shoot outside if at all possible. Natural light is much easier to work with because it's so even – on an overcast day, nobody gets lost in deep shadows or brilliant highlights. Don't shoot when the sun is low in the sky, because this can cast shadows on faces easily.

If you are forced to shoot inside and the group is large, use off-camera flash positioned overhead – from a beam, say. This gives more even illumination of everyone's face. Link it to the camera with an extension lead or use a slave cell. Alternatively, use more than one flash.

If the light level is reasonably high, you can use available light and a long exposure. Make sure everyone stays still!

Photographing babies

So far, we have been looking mostly at photographing adults – but for a lot of us, some of the most important people in our lives are not grown up yet. Fiona Pragoff gives David Jones a Masterclass in the difficult art of photographing babies.

I've photographed toddlers and older children before, but never babies, and in spite of having heard how difficult it is I was very keen to have a go. So I asked professional children's photographer Fiona Pragoff to show me how she goes about preparing and shooting the under ones.

We met up at Fiona's small studio in North London. To give us more scope, we'd chosen two miniature models for the shoot – an eight month old girl named Georgia and a seven month old boy named Felix. That way, if one of the babies wasn't in a good mood we'd be able to photograph the other one.

Awkward beginnings

I decided to go first, and chose little Felix as my model. After looking through Fiona's selection of canvas backgrounds, I picked out a subtle, mottled grey one. Then I turned to the lighting. Fiona suggested I use a softbox on one side for a soft light and a spotlight on the other to highlight the child's eyes. I decided to leave the background dark so the viewer's eye would be instantly drawn to Felix.

I asked Felix's mum to dress him in a pair of blue denim dungarees I'd picked out, then I sat him down in the middle of my set up. I waited a few minutes till he'd settled

The set up

Fiona and David were shooting in a small commercial studio. They both used the Mamiya RZ67, arranged very low on a tripod so that the 180mm lens was at the babies' eye level. They both used a softbox on the left of the babies for a general light, and a spotlight on the right to highlight the eyes. David used an unlit, grey background, but Fiona chose a far more cheerful blue one instead and used an umbrella on either side of the set up to light it. Fiona used a variety of rattles and toys to keep the babies interested and looking at the camera.

▼ *Fiona likes to include toys in baby shots from time to time – they keep the child happy and add interest to the picture. Little Georgia kept knocking these teddies over at first, but eventually she settled down and looked in the right direction.*

BEAUTIFUL BABIES

1 A BRIGHTER PICTURE

By choosing a light blue background and using two umbrellas to light it up, Fiona created a much more cheerful-looking set up. She dressed Felix in a stripy outfit and gave him a teddy to play with. She really took her time with him, and he looks much happier as a result.

2 SWAPPING BABIES

When Felix grew tired, Fiona decided to give him a rest and turned her attention to Georgia. She dressed her in a red shirt and blue jeans, and played with her for a few minutes before setting her down on the canvas. She shook a rattle to make the baby look at the camera.

▶ David asked Felix's mum to dress him in a lovely pair of blue denim dungarees for this picture, but unfortunately they were a bit big for him and ended up looking messy. A lack of light on the background has left the shot looking too dark, the baby's pose looks uncomfortable and there's dribble around his mouth.

down before I started shooting, but even then he didn't look all that happy.

I used Fiona's Mamiya RZ67 medium format camera with a 180mm lens and Kodak Ektachrome EPR ISO 64 slide film, but the resulting pictures were disappointing. They were all too dark, Felix's outfit was too big for him and his pose looked awkward and unnatural. Instead of being in such a hurry to take pictures, I should have spent more time getting to know Felix.

A lighter background

When Fiona took over, the first thing she did was change the background. She thought the grey one I'd chosen was too dull for a children's shot, so she replaced it with a cheerful blue one. She was happy enough with the way I'd lit the

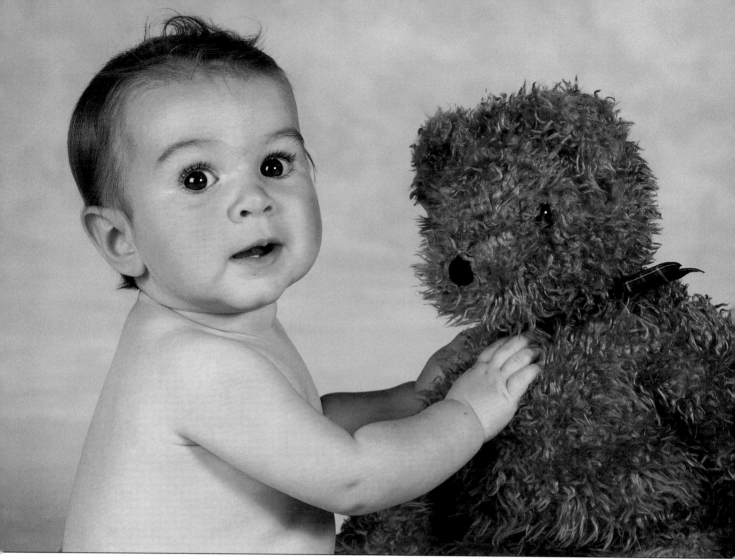

3 IN THE FLESH

To get a more natural looking picture, Fiona decided to try taking a close-up of Georgia without her clothes on. Initially the baby was a bit unsettled and began trying to crawl out of the shot, so a teddy bear was added to stimulate her waning interest. The spotlight shining in from the right of the set up has highlighted her beautiful eyes perfectly.

baby, but thought my background was far too dark, so she set up an umbrella on either side of her backdrop to light it up nicely.

Then she turned her attention to Felix. She swapped the baggy dungarees I'd chosen for a striped costume that fitted him better and looked more appropriate. More importantly, before she started shooting she spent a little time playing with him and putting him at ease. Only when she thought he was relaxed and happy did she begin shooting, using the same camera, film and lens as I had.

Switching models

By the time Fiona had finished taking a series of shots of a happy-looking Felix clutching a teddy bear, the little boy had begun to get tired. She could see he was about to start crying, so she decided to give him a rest and switch to our second model, Georgia. She dressed the little girl simply in a red top and blue denim jeans, and placed her down on the floor in the same spot where Felix had been.

While her assistant amused the baby by shaking rattles and making faces, Fiona took a series of pictures of a contented-looking Georgia on her own and surrounded by teddy bears. Then she tried photographing the baby without her clothes on to achieve a more natural look. The resulting shot of Georgia clutching her teddy bear worked very well, so Fiona decided to have a go at photographing both babies together in the flesh.

Two babies

By now Felix was rested and ready once again for action, so Fiona sat them both together in the set up

and waited to see what would happen. It was fascinating to watch the two babies gradually become aware of each other and start touching. At first they were a bit unsure of each other, but within minutes they were playing away happily, and Fiona was able to record the whole process on film.

4 MAKING CONTACT

Fiona then sat the babies down in the set up together to see what they made of each other. At first they were both a bit unsure, but curiosity soon got the better of them and they ended up playing happily. Fiona's method of gradual introduction made for some great pictures.

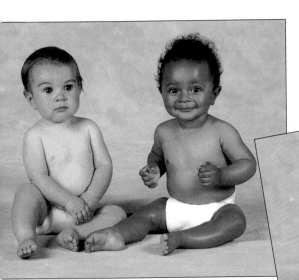

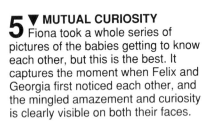

5 ▼ MUTUAL CURIOSITY

Fiona took a whole series of pictures of the babies getting to know each other, but this is the best. It captures the moment when Felix and Georgia first noticed each other, and the mingled amazement and curiosity is clearly visible on both their faces.

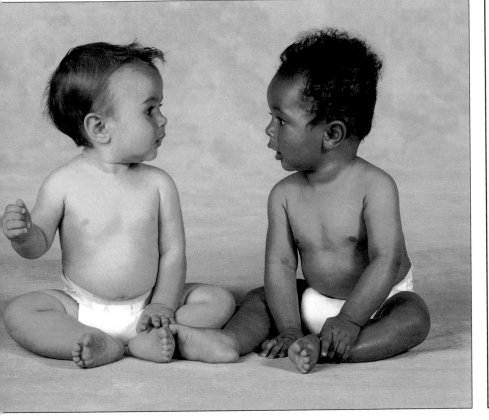

 Compact tip

❏ You can simulate Fiona's lighting set up very simply at home using daylight and your camera's flash. Use a large, non-sunlit window as the main light in place of the studio softlight, and let the flash add the sparkle provided in the studio by the spotlight. Set the camera's flash mode to fill-in (if it has that facility), but cover half the flash reflector with black card or a piece of tape so you can reduce the flash intensity.

 SLR tip

❏ The longer lenses generally used for portraiture aren't always necessary with children. You'll find it easier to tease great expressions from your subject if you use a standard 50mm lens and move in much closer. The standard lens distorts adult faces, but it's fine for children because their faces are considerably flatter. We're also used to seeing children from very close viewpoints, whereas we tend to stand further away when talking to an adult.

Ray Moller – Babies and children

'Photographing children is a real challenge', says Ray Moller, 'because they're so unpredictable. You never know at the start of a shoot exactly what you're going to end up with.'

Ray Moller has worked on shoots with kids of all ages, from toddlers to teenagers, and he divides them into three main categories. 'The first is babies', he says, 'and they're easy to shoot because they usually just lie there and gurgle. The most difficult age is from about 18 months to two and a half years. That's when they get curious and begin to move around very quickly. The last thing they want to do is sit still. But from two and a half on they're much easier to work with.'

He works in medium and large format and his lighting is usually very simple. 'I hardly ever use more than one main light', he explains. 'There's no point in rigging up an elaborate lighting set up only to have a child spoil it by moving around. I often use a softbox on one side and reflectors on the other – that's a very versatile arrangement.' Ray likes to use a long cable release in the studio, because it allows him to move around and keep his subjects amused. 'I sing songs, tell jokes – anything to keep them happy. But I enjoy it all because I love photographing children.'

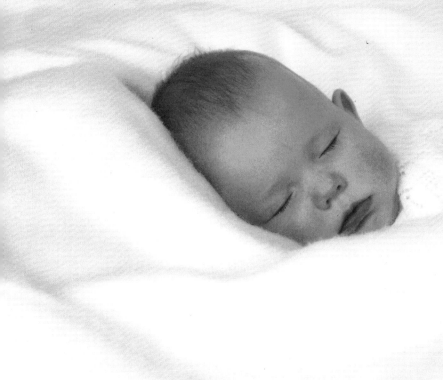

"There were four babies in the studio for this shot, and we had to wait for one of them to fall into a sleep deep enough to withstand a blast of flash. It was late in the day before this child finally dropped off – luckily he was the most photogenic of them all. I lit him from above, which gave a gentle, even overall light."
All pictures taken on a Hasselblad 500CM medium format camera, used here with a 150mm lens on Ektachrome 64 at 1/60th sec and f22.

"I'd originally planned to photograph these kids on a sun drenched jetty, but the weather put a stop to that. We'd just about given up hope and were driving back along the sea front when I saw this boat on the beach. We went down and as a last resort I asked them all to get into it. Once the children had settled down and were all facing the right way I started shooting. There was so little light that I opened the aperture right up to grab as much as I could. I was pretty sure the pictures weren't going to be good enough, so I was very pleased when I saw the results. I didn't need to use a filter – the mist gave me the soft focus effect I wanted."
Taken with an 80mm lens on Ektachrome 100 at 1/60th sec and f5.6.

Technical details

'I was looking for a suitably theatrical lighting effect in the shot below, so I lit it from below using two big softboxes. Lighting from below can be very effective for quirky, humorous images. You get much more form in the subject's face, and some interesting shadow effects. I also used a small light to pick out the outline of the boy's right hand and give the ball some sparkle.'

"I took a whole series of photographs featuring children dressed as adult sports stars for an advertising campaign, and this rugby portrait is one of my favourites. I hand-painted the background and then hung it up loosely to make it look less realistic and more like a canvas backdrop when thrown out of focus."
Taken with a 150mm lens on Ektachrome 64 at 1/125th sec and f16 with flash.

You can do it

'Below the age of four or five', says Ray, 'it doesn't really make any difference whether the child you photograph is a model or not. If you keep your subject interested and entertained, you'll be in with a chance of producing a decent shot. Blowing bubbles is a great standby, as are balloons. Choose a word that will make the kid smile just before you shoot – my current favourite is 'sausages'!

'None of this works with older children. If they want to be photographed they'll co-operate, but if they don't – forget it! At this age professional models are often easier to work with.'

"This was fairly easy to shoot. The little girl was in a co-operative mood, and I took the picture before the ice cream began to melt. It melts very quickly under studio lights, so it's best to have a few extra cones handy. I lit this with a softbox on one side of the girl and silver reflectors on the other. I only had a small amount of background to work with, so I used a zoom lens to narrow the angle of the shot and help me avoid showing the cluttered studio behind."
Taken with a 250mm lens on Ektachrome 64 at 1/125th and f22.

"We were looking for a lot of movement in this picture, so I laid duvets down and asked the little girl to run up and down. The shot was taken for a magazine, and space was needed for text on the right hand side. So I made sure she was on the left of the frame every time I took a picture. I crosslit her from the side with one big light, and used a smaller light to fill in the shadows on the background."
Taken with an 80mm lens on Ektachrome 64 at 1/250th sec and f11.

Toddlers at play

A youngster who has just learned to walk makes a charming – and sometimes hilarious – subject for the camera. Toddlers are livelier than babies and, unlike older children, not yet embarrassed by the camera, so they offer you lots of potential.

In their eagerness to try out their new skill at walking, toddlers dart around with surprising speed, making framing and focusing a challenge. For easier picture taking, it helps to keep them occupied with a game, a toy, a pet or even their own toes!

If you don't have children of your own, ask a friend or relative if you can photograph their youngsters, preferably in their own home. With luck, they'll be so absorbed in what they are doing that you'll find it easy to start taking photos. Remember that children get bored easily, so keep picture sessions short.

▼ KEEP IT SIMPLE
As toddlers are small, any 'props' should help draw the eye to the subject, and not overwhelm it. By keeping the setting simple, as here, your attention is focused on the child's fascination with the puppy. Simple, natural lighting ensures that shadows don't detract from the scene's charm.

Here the furniture was simply cleared away to provide an effective – and free – background.

▲ BEACH BABY
There's something special about a beach that provokes youngsters into an explosion of activity that isn't always simple to capture on film. To make it easier, wait for a while – don't start shooting at once. When a toddler's energy is contained, quieter games begin, giving you time for focusing and framing.

The toddler's concentration allowed the photographer enough time to frame the picture properly.

Tip — Keeping kids in one place

Perhaps the hardest part of photographing small children is keeping them in the frame – they keep toddling off. Solve the problem by involving them with a toy or a task that is static and absorbing.

When children are scrambling on a climbing frame, for example, you'll have plenty of time to compose the shot – and a slide brings them back to exactly where you've focused, time after time.

▲ COLOURFUL CLOTHES
Children love playing in fallen leaves, and this little girl is no exception. Here the little girl's joyful pose and primary coloured sweatshirt overcome the lack of contrast on a sunless day.
A toddler's outfit doesn't stay clean for long, so you'll probably need to take a change of clothes for even a short trip.

▶ CLOSE CROPPING
It's easy for small children to become totally absorbed in what they're doing – this is an ideal time for capturing some memorable shots. A close viewpoint is essential for portraying concentration: a broader view here would have included the top of the boy's head, but might not have captured the intensity with which the young artist is drawing.

◀ PERFECT TIMING
The only way to be sure of capturing the smiles and laughter – and the scowls and tears – is to be watchful all the time and to keep your camera ready. With luck, you may be rewarded with a lovely expression like this one. A motor drive may let you take more than one image of a memorable event, but it won't help you if your camera is on the other side of the pool, so always be prepared.

Toddlers in rain or shine

As we have already seen, children are rewarding to photograph but also a challenge! Charming antics can drive you wild with frustration when you try to catch them on film. You can increase your chances of success by taking pictures out of doors. There's ample free lighting, and whether you're in a garden or park you can usually find a variety of backgrounds.

Warm, sunny weather offers you lots of scope for lively pictures. But don't put the camera away when the sun goes in – as you'll see from these pages, a dull day or even a rainstorm is no barrier to good photographs, provided your model's enthusiasm holds up. Toddlers having fun playing in the snow or dressed in colourful wet weather gear can be captured with any camera.

Take along a toy so the child can play happily while you're free to concentrate on getting great shots. You should find that after a while your subject forgets that you're there. If you're lucky, there'll be a family pet around or a place for the child to explore while you get on with taking pictures.

◀ EASY CHAIR
Photographing a moving toddler can cause problems – especially if you don't have an autofocus camera. One solution is to sit the child in a pushchair and have someone wheel it round. Most children quickly become interested in the passing scenery – and they can't run away!

For a different angle, shoot from above. Here the toddler's co-ordinating clothes add extra interest to the shot. Make sure your own shadow doesn't cut out the light and cast a shadow over the subject's face – you may need to use fill-in flash.

▲ SAY CHEESE
Crouch down to bring the camera in line with your subject's eyes and make them sparkle with life. Avoid shooting with the sun behind your back and shining straight into a youngster's face as this will make them squint.

It's worth enlisting a friend to help keep your subject alert – here the girl was amused by something out of shot to her left.

◀ PET APPEAL
Bored kids make bad pictures, so come prepared with games, pets and other distractions. Solitary children usually play different games from groups, so they may need extra entertainment. Here a tortoise brought a smile to the toddler's face and gave the photographer plenty of time to compose the shot. With a lively dog you may have more trouble!

▼ HIGH VIEWPOINT
You only need simple props to suggest an idea. Here the photographer made use of an overhead viewpoint to emphasize the smallness of the child in relation to the path and to convey the idea that any distance seems a very long way to a toddler.

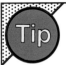 **Tip**

Leave plenty of space

Don't be tempted to frame your shot too tightly when you're photographing children. Because they can move quickly – especially when they're excited – it's all too easy to ruin the shot by accidentally leaving a hand or foot outside the frame if you've gone in too close. You'll kick yourself if you took a shot that can't be repeated.

Instead, take a few steps back and be prepared to improve the print's composition after the film has been developed. If necessary, order an enlargement so you can trim out unwanted areas without ending up with a tiny picture.

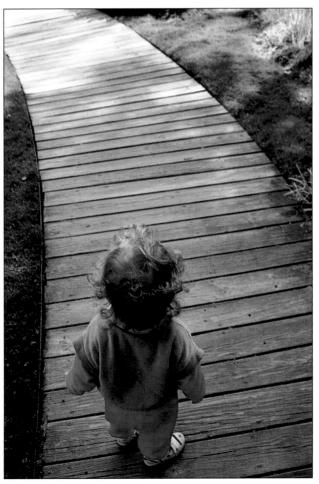

▲ RAINY DAYS
Taking your camera out in a light shower shouldn't do it any harm, but you'll usually get better pictures if you wait for the rain to stop. Rain puts a shine on everything and the sparkle fascinates tiny eyes (and fingers). To counteract the dullness of the weather, dress your subject in bright colours like a yellow coat, as here.

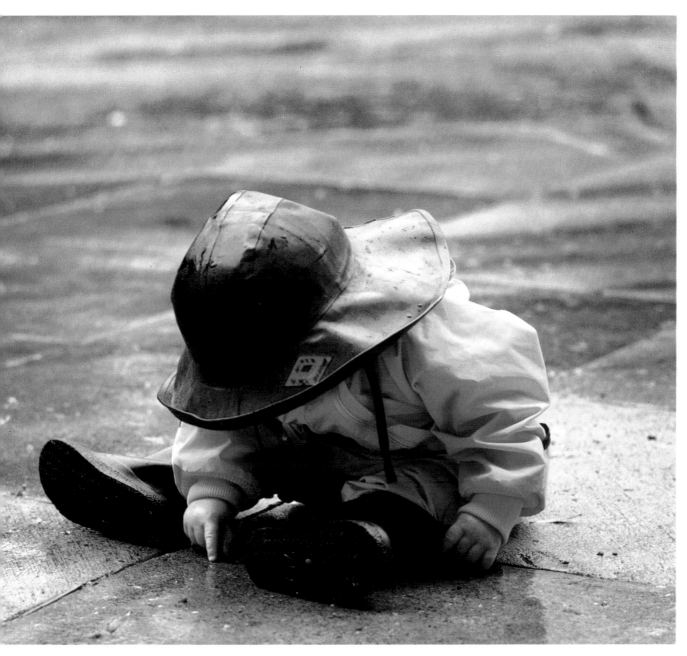

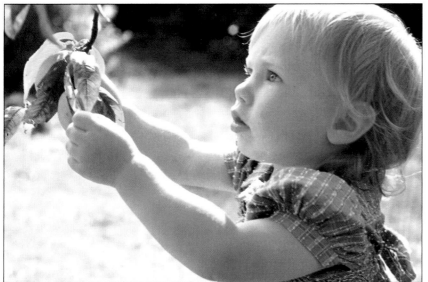

◀ HIGH LIGHTS
To banish shadows the photographer framed her subject against a brilliantly lit background. Pale hair can pick up the colour of the light easily. For a faithful record, take a high key approach and let light tones dominate the image. Tight cropping concentrates your attention on the girl, with no distractions in the background.

▼ WATCH THE BACKGROUND

An intrusive background can easily spoil a straightforward portrait. Position your subject against something plain, and pick a wide aperture to keep the background out of focus. If you have a long focal length lens (or a camera with a telephoto setting) use this to blur the background further. Here the girl is successfully isolated from the background.

► COOLING OFF

On a hot day, children play happily in water for hours, but you'll need to plan their antics if you want good pictures. Two children give you twice as much organization – but twice as many picture possibilities. Find a colourful tub and position it where there are no distractions – either for the children or for the camera.

▼ BEACH FUN

If you're taking sunny beach pictures, don't overdo it, particularly at the start of a holiday. Young skins are very sensitive to sunlight, and can burn before an adult even begins to feel the heat. Make sure children wear plenty of sunscreen and, after a few minutes, cover up bare skin with clothes. Remember to protect your camera from sand and salt spray.

Children at play

If you're patient and unobtrusive enough, young children will soon forget about you and your camera and get on with their games. Jenny Woodcock and David Jones look for candid shots in the playground.

It was a bright and sunny spring morning when the experienced children's photographer Jenny Woodcock and I arrived at the playground to set up this shoot. A group of six three-to-five year olds and their mothers had joined us for the day, and we began by persuading them to play about in the sandpit.

The children were reluctant to co-operate at first, but their mothers had wisely brought buckets, spades, dumper trucks and a variety of other toys along to produce in case of emergency. The toys did the trick, and before long the kids were digging away happily in the sand, completely oblivious to the cameras around them.

A frustrating start

Before I started shooting I walked around the verge of the sandpit for a few minutes looking for a good view of the children. The first potential picture I saw was two lads earnestly filling a dumper

▲ *Jenny watched this boy become more and more intent on filling his truck with sand for several minutes before closing in to take a candid upright shot.*

The set up

Jenny and David were photographing children in the play area of a public park. They began in the sandpit, which was enclosed on all sides by a low metal fence and surrounded by a grass verge. When the children tired of this they moved on to the playground, which included swings, slides, bouncing rides and wooden climbing frames. The day was sunny to start off with, but began to cloud over as the morning wore on.

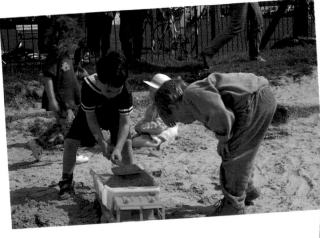

By shooting from almost the same level as the children David solved his background problems, and the simpler composition works better. Concentrating on a few of the children instead of the whole group was a good idea, but none of their faces can be fully seen, and one is completely hidden.

▲ *David was about to take a shot of these boys at play when they moved slightly so their faces could no longer be seen. The unsightly railings and passing children in the background add to the confusion.*

CANDID MOMENTS

1 TEAMWORK
Jenny noticed these two girls playing together away from the main group. She got as close as she could without disturbing them and began shooting. The girls' clothes add plenty of colour to the picture, and there are no unwanted distractions in the background.

2 CONCENTRATION
When the girls got bored with their game, one of them wandered off and began picking flowers. Jenny followed her back and forth and was rewarded with this lovely study. The girl's concentration as she carefully places the flower in the sand makes the picture special.

 Setting up a shoot

If you want to photograph children but don't have any of your own, a little organization will be required. You shouldn't just wander down to your local playground and start taking pictures without permission. Parents will get upset if they don't know who you are or what you're doing there. Ask a relative or friend with children to help you out. If the kids are supervised by a parent it will be far easier to get the pictures you want.

truck with sand. They hadn't spotted me so I crouched down, loaded my Olympus IS 1000 hybrid camera with Fuji ISO 100 slide film and began composing the shot.

The problem with children is that they never stay in the same place for very long. By the time I began shooting, the boys had turned their heads away from the camera so that their faces could no longer be seen. A busy, cluttered background didn't help matters either.

Looking for a less complicated shot, I zoomed in on one boy digging with two girls playing behind him. By getting lower and shooting down towards the sitting children I managed to solve my background problems, but including all their faces in the shot proved beyond me. I was beginning to realize that children are not easy subjects.

A simpler approach

Given the circumstances, Jenny decided to keep her shots simple and concentrate on one or two children rather than trying to photograph the whole chaotic group. She watched the children closely for a while, then noticed two little girls off in the corner of the sandpit playing by themselves. Using a Pentax ME Super with a 105mm lens and Fuji ISO 100 film, she took a lovely close-up of them building a sand castle together.

When one of the girls started playing with flowers on her own, Jenny moved in closer still to capture the moment. She stayed on the sand to take a lovely vertical shot of a boy concentrating hard as he filled his truck. But by now the children were getting bored, and a new location was required.

Swings and slides

The children were itching to have a go on the slides and climbing frames nearby, and Jenny decided to let them go ahead. 'It's never a good idea to force these situations too much', she says. 'It's always better to let them get on with it and

3 IN THE FRAME
When the children headed for the playground, Jenny was able to take a much wider variety of pictures. She spotted these two sitting in the climbing frame and rushed around to the front to take the picture. They saw the camera but by now were completely unconcerned by it.

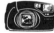 **Compact tip**

❏ Candid situations like this one give the compact user every chance of getting good pictures. Provided you remember to move in close and get down to the children's eye level, a sturdy compact will perform as well as the most advanced SLR. A zoom compact would be ideal.

 SLR tip

❏ If you want to get rid of a cluttered or unattractive background, use a long lens. Just open the aperture right up and get as close to the subject as you can. While your subject stays within the narrow focus band, the background will become blurred and indistinct.

4 A JOYFUL RIDE

The children were now totally relaxed and Jenny was able to get in as close as she liked without worrying about disturbing them. This allowed her to really fill the frame when shooting special moments like this one. The girl is clearly delighted by the bouncing seat.

see what you get out of the shoot. Besides, I had the feeling we might get something good in the playground.'

Jenny's feelings proved correct. As she followed them around the climbing frames they became less and less shy of the camera, and even began co-operating without ruining the spontaneity of the shoot. A candid shot of a little girl enjoying a bouncy ride was followed by a lovely picture of her and a friend smiling through the bars of a climbing frame. Jenny finished off with an unusual photo of one of the boys about to launch himself face first down the slide.

5 ON THE SLIDE

At first Jenny tried taking action shots of the children sliding, but they didn't work because the light was now a lot duller. Looking for something different, she focused on the top of the slide and caught this lad about to launch himself face first down the slope.

Children in the studio

Informal portraits of children are fine, but there is a certain charm in a more formal portrait too. Ray Moller shows Rhoda Nottridge how to take a studio portrait of Amy, our young model.

▲ *Rhoda Nottridge is a writer and keen amateur photographer.*

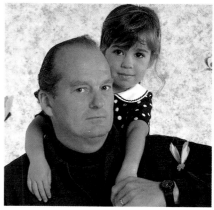

▲ *Ray Moller is a top professional children's photographer.*

Given the large choice of equipment available in Ray's studio, I felt spoilt for choice. I decided the best idea would be to keep everything as simple as possible. I chose to use Ray's Nikon F3 SLR with a motor drive and 50mm lens.

I asked Ray to choose a suitable slide film and he opted for Kodak Ektachrome ISO 100. Ray felt this would give an accurate flesh tone.

My next major decision was what lighting to use. My model Amy was impatient to get started, so I thought I would go for just one light, which I angled at the side of her face. Ray rigged up the light so that it acted as a synchronized flash linked on a cable to the camera. The flash also had a modelling light attached to it. This meant that I could see how the light would fall on Amy's face before the flash was fired.

By the time I had sorted out where to put the light, set up the tripod and worked out the exposure, I'd forgotten one of the most vital points – that poor Amy was only six and needed something to do. She was fed up by the time I'd finally finished pottering around. She had lost interest and I had lost all chance of a decent shot. It was time to put Amy out of her misery and hand over to Ray.

The studio set up

Using a studio flash, Ray had to shield the flash from the camera with cardboard. 'Unlike the flash attached to a camera, there is a danger of flare with a separate flash. Light could go from the angled flash to the camera. You don't even need cardboard. Just get someone to stand by the light to shield it from the camera.'

To make a backdrop, dye an old sheet a neutral colour and pin it up. Otherwise move in so close that all you see is the child.

Our background had a grey, mottled effect. To make one like this at home, dye an old sheet mid grey. Using a sponge, dab patches of fabric paint in lighter and darker shades of grey over it. To hang the backdrop, one option is to peg it to a washing line fixed between the top of a door and the top of a window.

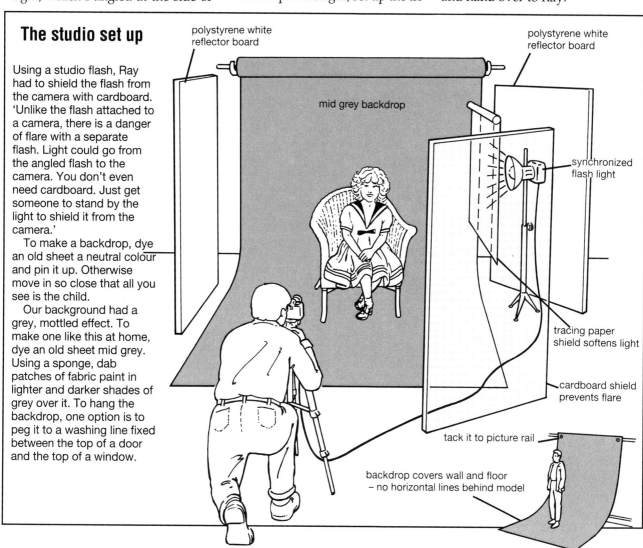

polystyrene white reflector board

polystyrene white reflector board

mid grey backdrop

synchronized flash light

tracing paper shield softens light

cardboard shield prevents flare

tack it to picture rail

backdrop covers wall and floor – no horizontal lines behind model

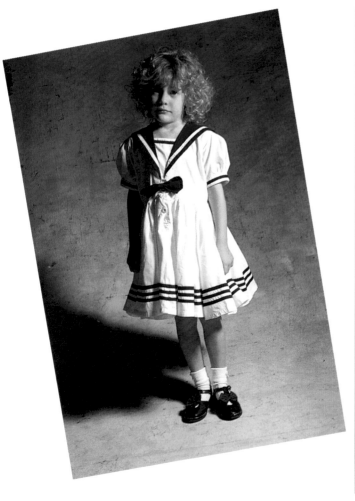

▲ *Rhoda was disappointed with the lighting in her photo. Because of a lack of reflected light, her left side is so poorly lit it is almost in complete darkness. This also creates an unpleasant shadow in the background.*

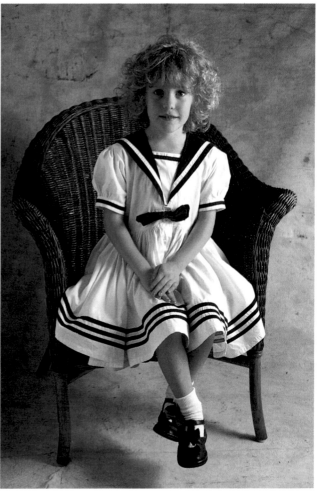

1 RELAXING AND REFLECTING
Ray's first move is to help Amy relax by sitting her down. He then puts a large piece of white board on the opposite side to the light source. This reflects light back on to the side of her face which is in shadow.

Playing games

When Ray took over he managed to bring Amy to life in seconds. He involved her at once by getting her to talk to him and smile by running through a menu of variations on the 'say cheese!' theme.

To encourage movement, Ray coaxed Amy into different poses by making it all into a big game. 'Put your hands up in the air...now put them down!' he cried playfully. Amy loved it.

Keeping it simple

Ray decided to stick with the backdrop I had chosen, which was a neutral mid grey colour. The advantage of this was that with different lighting, it could be made to appear very light or very dark, depending on the effect that was required.

Ray studied Amy for some time before even getting out the camera. He explained that the way he photographed her would partly depend on what she was wearing. 'There's no point in taking a picture of a girl wearing a pretty dress and then getting her to go crazy, leaping up and down and acting like a tomboy. You have to suit the shot to the mood that is created by the clothes a child is wearing.'

I wondered if Ray would use any props for his shot, as he had a whole box full of toys to occupy his young models in the studio. Ray replied, 'I try not to use props as they only complicate the shot. They're just another thing to worry about.'

Lighting up

Ray was quite happy to use just one light, as I had done, but with the intention of achieving somewhat different results. My shot had suffered from two major lighting problems. The side of Amy furthest from the light was thrown into darkness. Added to this, the light was casting a distracting shadow

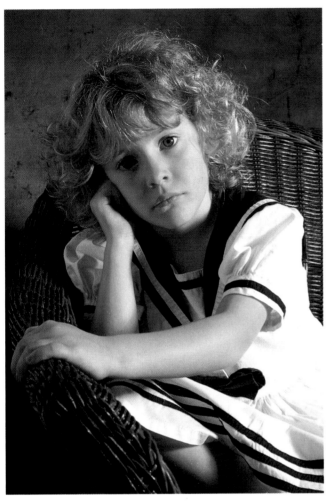

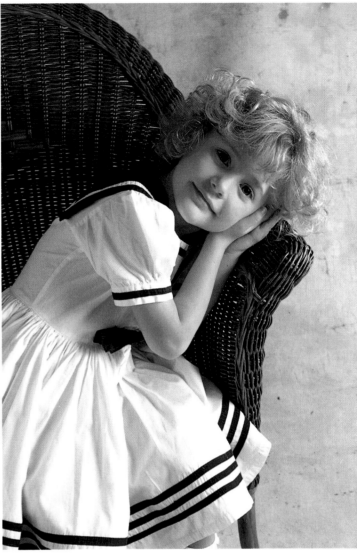

2 MOVING IN CLOSER
Ray notices that Amy's shoes do not really go with her dress, so he moves in much closer to keep her feet out of the shot. Ray also chooses a much heavier tripod, as the one I picked was so light it wobbled, preventing it from keeping the camera steady.

3 SOFTENING THE EFFECT
Ray softens the lighting further by adding another reflector to bounce more light back on to Amy from the front. This is exactly the same effect as if the light had been bounced from the corner of a room.

behind her.

Ray's first move was to put a large polystyrene board on the side of Amy furthest from the light source. Ray commented, 'I'm always looking at what's happening in the shadows. I can see by the contrast between one side of her face and the other that we need to throw light back into the shadowed side.'

As for the heavy shadow I had in the background of my picture, Ray pointed out that I would have had the same problem if I'd been using a camera with a direct flash. One way round this would be to stand the model right up against the

background. An alternative would be simply to move in closer to the subject and cut out the background altogether.

Reflected light
Ray used two reflectors – one opposite the light source and one in front of Amy. To soften the light coming from the light source, he put a tracing paper screen in front of the light.

Watching the considerable effort Ray put into getting the lighting right made me realize just how much difference correct lighting can make between a mediocre shot and a good one.

 Glowing results

Ray Moller says that using a soft focus filter can be helpful for softening portrait shots. 'A good quality filter such as a Hasselblad should tone down highlights. This gives the model a slightly glowing, softer appearance. Unfortunately although the Hasselblad filter is the best, it is also very expensive.' However, there are cheaper types of soft focus filters. With Amy's perfect peaches and cream complexion, Ray decided not to use a filter for these photos.

SLR tips

Light reading For our studio set up we had to do a light reading using an incident light meter. You can use this method at home if you have a light meter. To make an incident light meter reading, you take a reading of the light falling on to the subject, not the light reflected off the subject.

Ray Moller recommends: 'Take two readings from the face. Have the meter directed from the face to the camera for the first reading. For the second one, point the meter from the face to the light source. A correct exposure will be in between the two readings.'

Detachable flash You can hire a studio light from a professional photographic retailer but this is expensive. However, if you have a detachable flashlight, you can buy a synchronization cable quite cheaply. With this, you can fire the flashlight while it is detached from your camera.

To make the most of your model, you want to be sure you have positioned your light at a flattering angle. To check this, shine an ordinary adjustable desk lamp at the subject. Move it around until you have found the angle from which you want the light to shine. Then replace the lamp with your flash. Remember to turn off the lamp before you take your picture, so that only the flashlight is used.

You can get a friend to hold the flashlight in the position you want or fix it in place using an ordinary light clamp fixed on to a bookcase or other fixture.

Compact tip

A compact camera is not really suitable for this kind of studio shot because of the need for separate flash lighting. To achieve a good portrait with a compact it would be better to use the natural light of a window, or take an outdoor shot. If there is not enough light, then you could also use a fill-in flash if your camera has it.

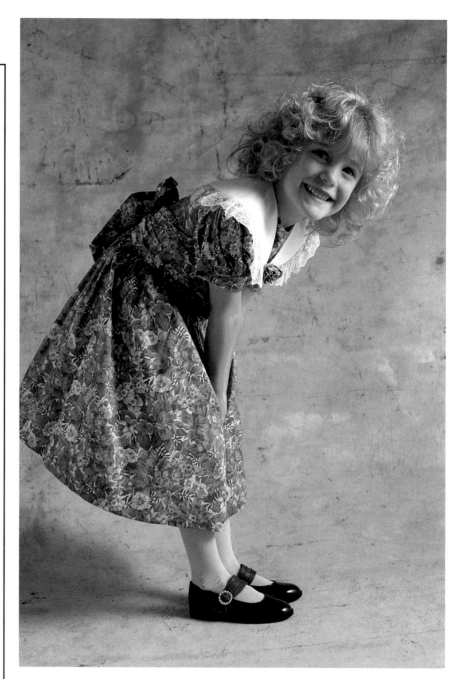

▲ *With Amy's pretty, curly hair, Ray felt a change of clothing would make a big difference to the shot. He chose a dress which suited her appearance and created a softer look for the shot.*

◀ *After a while, even a perfectly behaved child begins to get bored of being photographed. It's best to be prepared with one or two ideas to keep your young model amused. Ray let us into one of the professionals' secrets: bring along a pot of bubbles to blow! It never fails to liven up a bored child and provides some pleasing shots.*

Photographing your dog

Taking a dog's picture is no simple matter. Often you're so busy trying to keep it still that the shot itself gets rushed. But as Mike Henton shows David Jones, a little extra care will give you the photo you want.

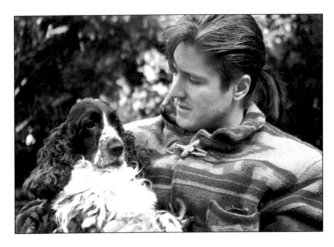

► *Mike Henton is a professional fashion and location photographer. His appealing dog, Harri, is a sweet-tempered spaniel.*

When Mike Henton and I met up for this masterclass, our task seemed a fairly easy one. All we had to do was take a picture of his well behaved little dog Harri. The weather was definitely in our favour – it was a clear, sunny autumn morning – and Harri seemed to be in a co-operative mood, so how could we go wrong? Needless to say, it didn't turn out to be as simple a job as I'd thought.

We were working in a large and spacious garden which gave us several different backgrounds to choose from. We decided to try shooting with compacts so we could act quickly – you can't ask a dog to hold the pose! Mike was using an Olympus AZ 210 zoom compact, and I chose an Olympus AZ 330. I was due to start first, so I attracted Harri's attention and began shooting.

A view from above

Some dogs won't keep still for a second, but Harri was as good as gold to begin with. She sat when I asked her to and stared dutifully into the camera. However, this happy state of affairs didn't last long. Harri's used to being photographed by Mike, and she knows what's expected of her, but she won't do it for long unless she's regularly rewarded. So we produced a bag of sweets at regular intervals to keep her happy (although dog biscuits are kinder on a dog's teeth).

Once the dog was sitting down on the grass, I stood above her and waited for her to look up. When she did I pressed the shutter. I was hoping that the view from above would give me an interesting shot, but Harri looks lost in the grass around her, and her nose has been elongated by the strange perspective. It would have been a much better shot if I'd brought the camera down to the dog's level.

Dog's eye view

That's just what Mike did when he took over. First he got down on one knee and took a similar shot to mine but from a much lower perspective. Harri was still sitting down, but was now able to look directly forward at the camera. Because she wasn't straining her neck upwards she looked far more natural.

The set up

Mike Henton and David Jones were working in a large back garden with a grass lawn, a gravel path and plenty of trees. Both photographers used Olympus zoom compacts and Fujichrome ISO 200 slide film. They shot early on a sunny autumn morning in perfect visibility.

David started shooting first, using only the lawn as a background. But Mike moved the dog around and tried several different spots when he took over. He used a golden reflector to make sure that Harri's eyes weren't lost in the black fur around them, and a packet of sweets to keep her happy.

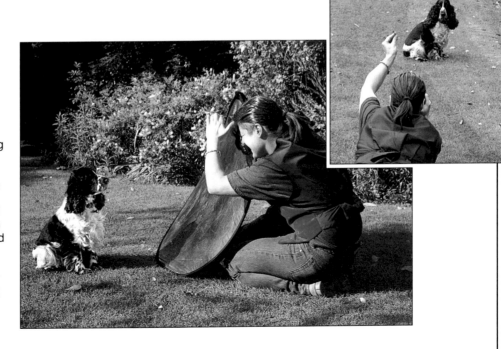

◀ *David was so surprised at Harri's initial good behaviour that he jumped into action while the going was good. He positioned himself directly above the dog and started shooting as soon as she looked up. There's plenty of light in the shot but Harri looks lost in the grass background and only a small amount of her is visible. 'He had no chance of taking a decent shot standing up', explains Mike. 'You have to get right down to the dog's level.'*

Then Mike persuaded Harri to lie right down and he did likewise, resting on his elbows to keep the camera steady. He was now as low as he could get, and this gave him an excellent front-on view of the dog. When he zoomed in he produced a charming shot that was full of character.

But he wasn't completely happy with the background. He started on the grass, and then tried some shots on a gravel path with trees in the

A LOWER ANGLE

1 SITTING UP
Mike didn't change Harri's pose at all in his first shot – she's still sitting up and looking at the lens. The difference is Mike is down on one knee, almost at the dog's eye level. This means that Harri's looking straight ahead instead of up.

2 LYING DOWN
Unhappy with the grass background, Mike moved Harri on to the gravel path and asked her to lie down. Then he did the same. The lying posture allowed Mike to concentrate on the dog's face. He placed a sweet on the ground in front of Harri to make sure she kept her nose down.

3 ZOOMING IN
Mike has zoomed in so that Harri's face now dominates the frame. He's changed her position too. By holding a sweet above his head he managed to persuade the dog to lift her nose and turn slightly to one side. Her expression is perfect but the background is quite distracting.

Tip

Dealing with dogs

Here are some more useful dog handling tips:
❏ When photographing long-nosed breeds full face, it's very difficult to get both the nose and the eyes sharp. Try shooting in profile instead.
❏ Dogs hate jumping downwards, so placing a

frisky hound on top of a low wall may help keep it still. Another way of slowing down a lively dog is to put a hot water bottle in its basket – it will curl up on the warmth. On the other hand, taking a sleepy dog out of a warm house into the cold winter air will help make it look more alert for

the cameras.
❏ If you use food for encouragement, choose the semi-dry dog snacks. Unlike tinned food, they don't leave greasy marks around the animal's mouth that you only notice when you get the film back.

background. But this was too distracting, so he sat her among the autumn leaves. At first Harri looked lost in the brown and green, but when Mike zoomed in on her the leaves were thrown out of focus to create an effective background.

Handling Harri

'My biggest worry when photographing Harri is always her eyes', explains Mike. 'They're dark brown and the fur around her eyes is black, so they often disappear completely on film. To pick them out, I use a golden reflector. This should work with most dogs.

'Working with dogs can be infuriating at times, but there are certain things you can do to make life easier. Photographing your own dog is always easier, because it's more likely to do what you tell it. But whether the dog is yours or not, you should speak firmly and clearly to show it you're the boss.

'Try to let your dog know that it's working with you. A bag of sweets or biscuits comes in very handy if all else fails. If possible, try to make sure your subject doesn't eat or drink for a couple of hours before the session. This will make the dog more eager for the rewards, and will avoid the problem of it cocking its leg at an inappropriate moment. The nicest thing about working with animals is that a shoot is never predictable.'

4 CHANGING BACKGROUND

Unhappy with his background, Mike found a spot where the sun was lighting up the autumn leaves and sat Harri down in them. He was hoping that her black and white coat would stand out against the pale autumn colours. He shot on one knee again and from slightly above her to emphasize the contrast. Unfortunately, the sun is so bright that the leaves look very vivid on film and the dog seems lost among them.

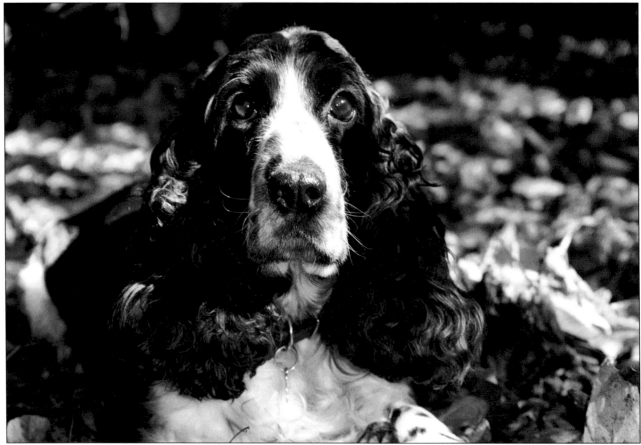

5 FOCUSING ON THE FACE

Mike finally solved his background problems by closing in on Harri's face. By zooming in close he threw the leaves out of focus to create a very effective backdrop. Because she was looking straight at the lens, her eyes had to be perfect. So Mike balanced a golden reflector beside him as he lay on the ground. This threw enough light on to Harri's eyes to bring out their colour. A bag of sweets later, Mike had the shot he wanted.

 Compact tips

❏ Most compacts cannot focus on objects that are nearer than about 60cm. So if you want to fill the frame with your dog's face as Mike did, either use the zoom instead of moving closer or crop the picture afterwards.

❏ Focus lock is a great help when throwing your background out of focus. It lets you hold your focus on the subject and leaves you free to move around and recompose.

 SLR tip

❏ If you have the choice, an autofocus SLR is more suitable for animal photography than a manual camera. Stopping for minute focusing and exposure adjustments might mean the difference between getting a shot and missing it when photographing an easily distracted dog. The speed and ease of use of an autofocus camera can be very handy.

Photographing your cat

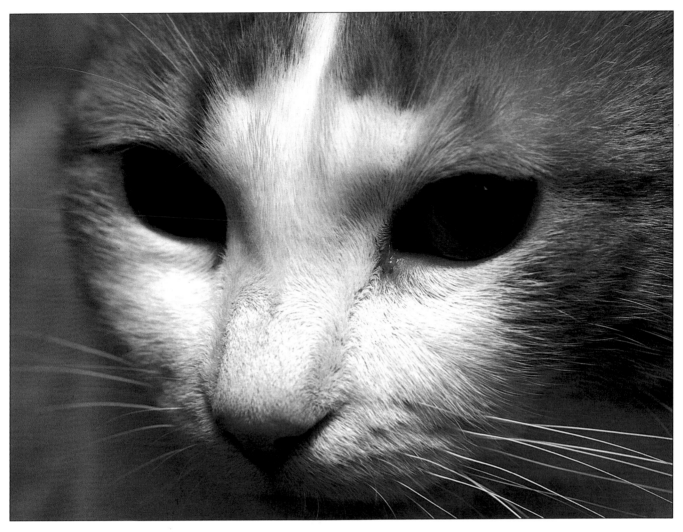

Cats are very photogenic animals, but they hate staying still and they're hard subjects to reason with. Jerry Young shows Louisa Somerville how to make the most of limited opportunities.

▲ *Jerry initially tried taking some close ups of the cat's face without flash. This one's quite successful, but there's not quite enough light, and with the aperture right open not all of the face is sharp.*

▲ *Jerry Young is a professional editorial and animal photographer.*

I've tried photographing Tom, my ginger cat several times before, but without any success. Either he moves at the last minute or the background and lighting are all wrong. With so little time to set up and focus a shot, my exposure is nearly always incorrect. But he's an attractive cat and I've always wanted a decent picture of him, so I asked animal photographer Jerry Young to show me how it's done.

The morning Jerry arrived at my house Tom was in an excitable mood, and he became even worse when he sensed the presence of a stranger. He raced around the living room, then hid behind the record player, and it took me a long time to persuade him to stay in one place for more than a few seconds.

The set up

Louisa and Jerry were photographing her ginger cat Tom in a small, dimly lit north facing living room. The weather outside was overcast and dull, which meant there was even less available light in the room than usual.

The cat was very nervous at first, and when Louisa tried using direct flash he went into hiding. She then tried available light, but her shots were too dark. Jerry started by using window light, but switched to flash bounced off the white ceiling for most of his photographs to boost the low light level.

▼ *Having failed with direct flash, Louisa had to rely on natural light. But because the sofa was quite far from the window there wasn't enough. The shot's not quite sharp either, with too much couch and not enough cat.*

Lighting problems

I drew the short straw and started shooting first, using a Nikon F3 with a 35-70mm zoom lens and Kodachrome ISO 200 slide film. The room was quite dark, so I decided to use flash. Tom was a little calmer by this time, but when the flash gun went off he disappeared under the sofa like a shot.

Flash was obviously not a good idea at this point, so I had to make do with the available light from the windows. I talked Tom out from under the sofa and then photographed him sitting on it.

Sadly, even my best shot was a bit too dark, and didn't really do justice to Tom's ginger coat. It was far from perfect, but I was happy just to have taken a picture that actually included the cat!

By the window

To avoid using flash until the cat was more used to the camera, Jerry decided to try some shots beside the window. He wanted Tom to look out of the window so he could shoot him in profile, so he asked me to go outside and tap on the glass to attract his attention. The

JERRY'S APPROACH

1 ▲ WINDOW LIGHT
To avoid using flash until Tom was more relaxed, Jerry decided to shoot at the window. Louisa stood outside and tapped the pane to keep him interested, and Jerry used ISO 400 film to grab all the light he could.

2 ▶ ON THE SOFA
When Tom moved over to the back of the sofa, Jerry pulled back to include a straw hat above in a balanced composition. He used flash but bounced the light off the white ceiling above and switched to ISO 64 film to get better image quality.

ploy worked, and Jerry was able to take a nice series of shots, using a Nikon F3 with a 35mm lens and Kodachrome ISO 200 slide film. He bracketed widely to cope with the low light, but they were still a little too dark.

Bouncing flash

By now Tom seemed calmer and more comfortable, but even so direct flash would have unsettled him again and caused severe red eye problems. To avoid all this Jerry decided to bounce light off the ceiling. 'Luckily it was a pure white ceiling', he explains, 'so it gave a nice, soft light. Direct flash would have been very harsh in comparison. I switched to Kodachrome ISO 64 for these shots, because the quality is much better than ISO 200 and I wasn't struggling for light.'

The cat was now sitting on the back of my sofa, and there was a straw hat hanging on the wall immediately above him, so Jerry drew back to include it in a well composed long shot. Then he decided to make use of my piano to try a more unusual set up. He lit candles at either end, opened a book of sheet music in the middle and got Tom to walk along the keys. The result was eerie and effective.

Close ups

Jerry then sat Tom on the sofa as I had and took some close ups. He switched to a 105mm lens so he could shoot without getting so close that he frightened the cat, and lit them with bounced flash as he had before. He took a lovely front on shot of Tom's face and chest and finished off by going in even closer for a profile.

3 A TOUCH OF MAGIC
Jerry included Louisa's attractive piano, as he decided it would make a great backdrop for a more imaginative shot. Tom walked obediently up and down the keys, and the candles have added a touch of warmth to the overall light.

Tip **Patience and pre-planning**

'Cats are definitely the most difficult animals to photograph', says Jerry, 'because they're completely independent and have a mind of their own. They're not at your beck and call like dogs are, so reserves of patience will come in handy. You can make your shoot easier by watching your cat's behaviour beforehand. Find out where it likes to sit and at what time of the day. It's more likely to stay in its favourite spot when being photographed.'

❏ Direct flash will look very harsh in close-ups, and is bound to cause red eye problems. You'll be better off using window light, which can be perfect on a sunny day, or using tungsten film and an angle poise lamp. If you can't turn the flash off on your compact, use a faster film and stick to available light.

❏ When shooting close-ups indoors in available light, be especially careful about your focusing. You'll probably need to shoot with the lens aperture right open to gain enough light, but this will leave you with a very narrow band of focus, so the slightest movement might leave part of the cat's face unsharp.

4 ◀ **HEAD AND SHOULDERS**
Jerry switched to his 105mm macro lens to take close-ups of the cat's face. He waited until Tom was sitting comfortably on the sofa before he shot this front on study. He knelt on the carpet so he was shooting at the cat's eye level.

5 ▼ **A PROFILE**
To finish off Jerry decided to move in even closer and concentrate on the cat's head. He tried a few different viewpoints before deciding that a profile would be his best bet. It made an unusual but very effective study.